Images of Modern America

SIX FLAGS GREAT AMERICA

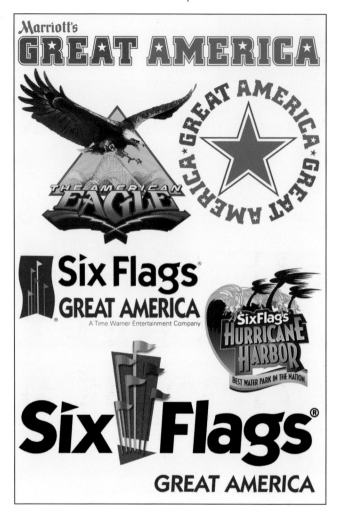

The original Marriott's Great America logo was used from prior to the 1976 opening year up through the spring of 1984, when it was modified for Six Flags (as seen on page 65). The 1981 logo for the American Eagle is possibly the most beautiful roller coaster logo ever. The round Great America symbol dates back to before the park's 1976 opening. The Time Warner version of the Six Flags logo was introduced in 1993. Introduced at the park in 2005, the Hurricane Harbor logo has evolved to the form appearing here. The current Six Flags Great America logo, at bottom, has appeared in various forms since 1999. (Courtesy of Six Flags Great America.)

FRONT COVER: Shortly before opening day, May 29, 1976, Marriott's Great America employees gathered for a family portrait at the Columbia Carousel and its reflecting pool. (Courtesy of GREATAMERICAparks.com.)

UPPER BACK COVER: At Marriott's Great America, guests could travel high above the park on the Southern Cross skyride, spin above the park on the Sky Whirl triple Ferris wheel, and experience the thrills of the Turn of the Century roller coaster, all seen in this photograph. The vacant land beyond the roller coaster is now the Southwest Territory. (Courtesy of GREATAMERICAparks.com.)

LOWER BACK COVER: (LEFT) Two boys with BUGS BUNNY™ ears are eager to enjoy a ride on the Big Top, which is now located in Southwest Territory and is known as Ricochet. (Courtesy of GREATAMERICAparks.com.) (CENTER) A thrilling ride on the Tidal Wave roller coaster made a lasting impression on many a guest. (Photograph by author.) (RIGHT) Entertainment was everywhere at Marriott's Great America. The LOONEY TUNES™ characters mingled with the guests, performed in Theatre Royale, and appeared in the Merry Mardi Gras Parade. The Great America Singers, on the balcony above, performed Broadway-style musicals in the Grand Music Hall. Street musicians, marching bands, and other performers added to the incredible entertainment lineup. (Courtesy of GREATAMERICAparks.com.)

Images of Modern America

SIX FLAGS GREAT AMERICA

Steven W. Wilson

ARCADIA
PUBLISHING

Published by Arcadia Publishing
Charleston, South Carolina

Printed in the United States of America

Library of Congress Control Number: 2016959654

For all general information, please contact Arcadia Publishing:
Telephone 843-853-2070
Fax 843-853-0044
E-mail sales@arcadiapublishing.com
For customer service and orders:
Toll-Free 1-888-313-2665

Visit us on the Internet at www.arcadiapublishing.com

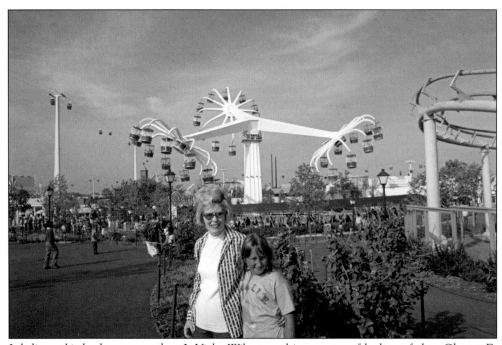

I dedicate this book to my mother, J. Violet Wilson, and in memory of both my father, Chester E. Wilson, and my sister, Shelle. My mother and sister are seen here during a visit to Marriott's Great America in Gurnee. (Photograph by author.)

CONTENTS

ACKNOWLEDGMENTS

I extend special thanks to Katy Enrique and Tess Claussen of Six Flags Great America, as well as Hank Salemi, park president, for making this book possible.

Special, heartfelt recognition and eternal gratitude go to Angie Lovell McAvoy, Kristopher D. Jones, and Kyle Smith for going far above and beyond to assist with the making of this book. Their exceptional contributions significantly enhanced the quality of this book. And their love for this park and its history is immeasurable. Special recognition and gratitude also go to David L. Brown, former vice president, Theme Parks Group, Marriott Corporation.

Those who contributed photographs to the book are also greatly appreciated. Many important photographs appearing in the book were graciously provided by Dan Berg, David Carter, Sheila Dissmore, Todd Doerge, Scott D. Farrell, Phill Greenwood, Johnny Heger, Michael S. Horwood, Ryan MacKenzie, Duane Marden at rcdb.com, Jon Revelle, Morgan Richardson, and Mark Rosenzweig.

In addition, I would like to thank the following current and former employees of Marriott's Great America, Gurnee or Six Flags Great America or both for their valued assistance: Dave Arnold, James Bouy, Ann Boynton, Kellie Brown, Margie Gillis-Moss, Hamp Howell, Ron Johnson, Eddie Katich, Jerome Knull, Jerry Moore, Mike Newton, Bruce Pfeffer, Rob Proce, Sandy Quinn, Jan Schefstad, Lisa Ignoffo Scheuring, Eugene Schmidt, Peter Schneckloth, John Tarr, Dave Wolowic, and Jim Zradicka, as well as the entire Six Flags Great America team.

Special thanks go to Roger Ross of California's Great America and Raul Rehnborg, vice president and general manager of California's Great America, for access to rare Gurnee materials in their archives. I greatly appreciate the kind assistance I received from Jeff Brown, Joseph DiMarco, Darren Foland, Dennis Foland, Judi Hadfield, Michael Lynch, Dave Murphy, and John Poimiroo, all from Marriott's Great America, Santa Clara, California.

From Marriott International, Inc., I wish to thank Katie Dishman, corporate archivist of the Marriott Corporate Archives, for her wonderful assistance.

From the Village of Gurnee, I thank Jack Linehan for his valuable assistance. From the Warren Township Historical Society, I extend my gratitude to Joe Lodesky and Michael Weiland for their help.

I extend my special thanks to Anne Thomason, archivist and special collections librarian at Lake Forest College, for her kind research assistance. At the University of Tulsa, I thank Andra J. Lupardus, McFarlin Library reference librarian, and Liz Buckley Sanchez for all their help with research. Thanks, too, go to Dona Davidson, reference librarian at Oklahoma State University–Tulsa.

Others I thank for their help include Paul Asente, Don Azars, Tom Benton, Robert Bleck, Tom Bleck, Jim Figley, Darren Hudson, Chris Kearsing, David Lipnicky, Joe Lopez, Stacy Figley Moore, Jason Rotunda, Jeff Ruetsche, Raymond Scott, Rene Scott, Tom Schott, and J. Violet Wilson.

Unless otherwise noted, all photographs appear courtesy of Six Flags Great America.

INTRODUCTION

Six Flags Great America opened as Marriott's Great America on May 29, 1976. By the early 1970s, tremendous growth in the theme park business led to Marriott Corporation's decision to develop its own theme parks. The first Marriott's Great America entertainment center, proposed to be built midway between Baltimore, Maryland, and Washington, DC, was announced on January 26, 1972. Plans called for a theme park, a marine life park, a wild animal safari park, hotels, a campground, shopping, restaurants, and other entertainment. Later, Marriott's Great America parks were announced for Santa Clara, California, then Gurnee, Illinois. Local opposition to the Washington, DC, area park halted its development both at the Maryland site and later at a backup site near Manassas, Virginia.

David L. Brown, vice president of Marriott's Theme Park Group, was tasked with creating the Marriott parks. He assembled a team of top talent that was recruited from industry leaders such as Disney, Six Flags, and Cedar Point. Many were eager to join Marriott for the extraordinary opportunity to create world-class theme parks from the ground up.

Marriott hired Economic Research Associates to conduct feasibility studies. The firm was founded by Harrison "Buzz" Price, who served as a consultant to Walt Disney in the selection of locations for Disneyland and Walt Disney World. The studies for Marriott revealed that the best markets for a new regional theme park in the United States were Baltimore/Washington, Chicago/Milwaukee, and the San Francisco Bay Area. The village of Gurnee, midway between Chicago and Milwaukee, stood out as an ideal location for Marriott's Great America.

Randall Duell and Associates of Santa Monica, California, was hired to design Marriott's Great America. Architect Duell started a small firm in Los Angeles in 1937. With demand for architects low because of the Great Depression, Duell worked in Hollywood as an art director for more than 30 MGM films, including *Singin' in the Rain*. Duell left the movie business and founded his new design firm at the age of 55. His company's first job was to design Six Flags Over Texas for the Great Southwest Corporation in Arlington, Texas. He went on to design the other two original Six Flags parks, in Georgia and Missouri, as well as nearly every other major regional theme park in the United States.

Duell set out to make Marriott's Great America his finest yet. Marriott researchers combed the country to find authentic artifacts to enhance the historical theming of each of the park's sections: Hometown Square, Great Midwest County Fair and Livestock Exposition (aka County Fair), Yukon Territory, Yankee Harbor, and Orleans Place. Also planned but deferred for a future expansion was the Great Southwest.

For a grand entrance, Duell designed the spectacular Columbia Carousel, situated at the end of a huge reflecting pool. The ornate structure housing the double-deck ride would reach 10 stories high. Many of the country's rarest carousel horses and figures were reproduced for the Columbia Carousel. The rare originals were loaned to Marriott so that molds could be made directly from them for the reproductions.

The entrance area would be named Carousel Plaza. From there, the five themed areas were joined so that a path leading from one section to the next would eventually loop back to Carousel Plaza. This design feature, common in Duell's designs, was known as a Duell loop. The loop ensured that guests would pass through all of the themed sections without bypassing any of them. At Marriott's Great America, the center of the loop served as a service corridor. Each of the themed sections could be serviced from the center of the loop without interfering with the guests' experience.

Marriott's Great America opened with one of the finest collections of rides in the country. Arrow Development Company of Mountain View, California, supplied major rides such as the Turn of

the Century roller coaster and the massive interlocking flume rides. Many of Europe's best ride offerings were imported via Intamin, Inc. These included the thrilling Whizzer, designed and built by the team of Anton Schwarzkopf and Werner Stengel, and the world's first triple Ferris wheel. A June 1975 announcement informed that four more rides would be added to the park's lineup to better serve the expected opening year crowds: Traffique Jam, Cajun Cliffhanger, Spinnaker, and Whirligig. These rides would not be added to the California park.

The shows were as important as the rides. Franklin Eugene "Gene" Patrick, vice president of show operations, was responsible for every aspect of entertainment in the park. Patrick started as a trumpet player at Six Flags Over Texas. He rose to positions of increasing importance at Six Flags and also served as general manager of the Astroworld and Carowinds theme parks prior to joining Marriott. A musical genius, Patrick was also an architect. He worked closely with Randall Duell on the design of the theaters at Marriott's Great America. Patrick and Tom Merriman wrote and arranged all of the park's original music. Merriman's company, TM Productions of Dallas, Texas, was a leader in the production of advertising jingles and specialty music.

Choreographers for Marriott's Great America shows were Jim and Judy Bates. As a boy, Jimmy Bates appeared with Fred Astaire in the film *Easter Parade*. He choreographed numerous television shows and specials, creating dance moves for performers such as Lucille Ball and Dolly Parton, among many others. Costumes for the shows were designed by Pat Campano, who had also designed for the Supremes and the Jackson 5.

Food at Marriott's Great America was intended to be superior to typical theme park fare. In addition to traditional theme park favorites, Marriott pursued serving a greater variety of foods at higher quality, including foods that were appropriate in theme to each of the park's sections.

A Marriott innovation in theme park merchandising was to make shops part of the show, too. A variety of craftspeople were hired to demonstrate their crafts and sell their creations in shops at the park. These included glassblowers, glass cutters, candlemakers, potters, wood-carvers, broom makers, and more. Shops also sold plenty of souvenirs. Many of the most popular souvenirs featured BUGS BUNNY and the LOONEY TUNES characters. In harmony with each park section's theme, finer merchandise, such as Hummel figurines, also could be found in the shops.

After creating this magnificent park and successfully running it for eight seasons, Marriott's plans to exit the theme park business led to the April 1984 announcement of an agreement to sell the park to Bally Manufacturing Corporation, then owner of Six Flags. Building on the Marriott foundation and bringing Six Flags' years of theme park experience, the park has continued to innovate, grow, and thrive ever since.

Chapter 1 presents a look at the planning, design, and construction of Marriott's Great America. Chapter 2 offers a tour of the park during the Marriott years, passing through each section in physical order, going from Carousel Plaza and Hometown Square around to Orleans Place. Chapter 3 provides a look back at highlights of the changes and additions that Six Flags has made since 1984. Within the space limitations of this book, I can only give you a small taste of the richness of this park's history. I wish that I could have shared more photographs and information with you here. I hope the book will bring back fond memories of happy experiences that could have happened only at Gurnee's Six Flags Great America, which began as Marriott's Great America.

One

BUILDING MARRIOTT'S
GREAT AMERICA

Word about a planned giant amusement park west of Gurnee began to spread thanks to an August 23, 1972, article in the *Chicago Tribune*. The article reveals that land had been purchased to assemble a park site of at least 250 acres. Because the theme park project was confidential, sellers were not informed of the real reason for the land purchases. On January 29, 1973, plans were officially announced for Marriott's Great America to be built on a 600-acre site adjacent to the village of Gurnee, Illinois. (Courtesy of Phill Greenwood.)

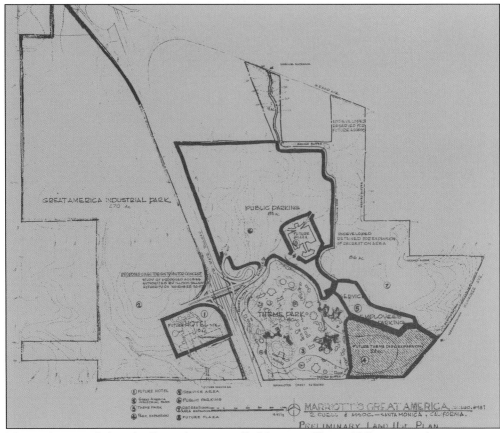

Marriott's original plans for Great America called for a new Illinois Tollway interchange to serve the park to the east and a future Marriott hotel and industrial park to the west. All public access to Marriott's Great America would have been exclusively via the new interchange. This was to keep local roads free of park visitor traffic congestion. The Illinois Tollway did not approve the proposed interchange, resulting in Great America visitor traffic primarily accessing the park from Grand Avenue. Also included on the site plan is a future plaza. This was to have been an enclosed, themed shopping mall featuring retail, dining, and entertainment for year-round use. (Courtesy of Marriott International corporate archives.)

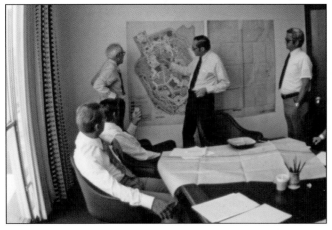

At the design firm's offices in Santa Monica, California, Randall Duell looks on as David L. Brown discusses the working site plan for Marriott's Great America. Brown was the head of Marriott's Theme Park Group. It was his responsibility to get both Marriott's Great America parks—in California and Illinois—designed, built, and operating. (Courtesy of Morgan Richardson.)

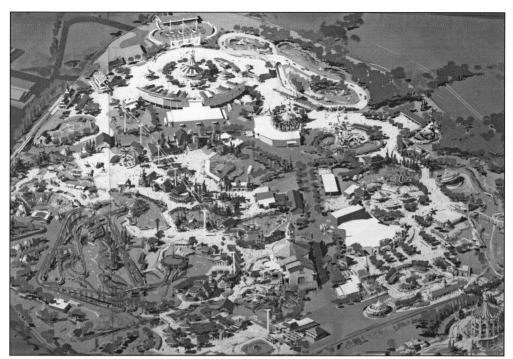

This Duell rendering of Marriott's Great America comes close to representing the park as it was originally built. Key differences between the rendering and the actual park that opened in 1976 are that the Turn of the Century roller coaster, later converted to the Demon, was absent and the large American Heritage Theater in Yankee Harbor was omitted from the park. Without the theater, Yankee Harbor was the only themed section of the park not to have a major show venue. The theater's site was used for the Tidal Wave and, later, the BATMAN™: The Ride roller coasters.

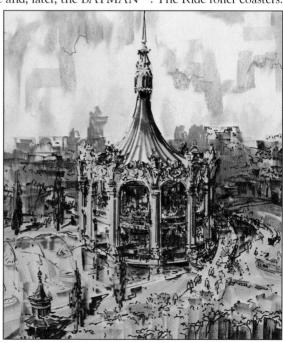

A grand entrance to Great America was an important design requirement for the park. Designed by the Duell firm, the Columbia Carousel would serve as a dramatic, memorable sight for visitors to Great America. This million dollar carousel, the most majestic built in the United States in decades, even had its own song, written and produced by the team of Gene Patrick and Tom Merriman. The "Carousel Song" was played at the opening and closing of the park each day. It is still played at the closing. (Courtesy of GREATAMERICAparks.com.)

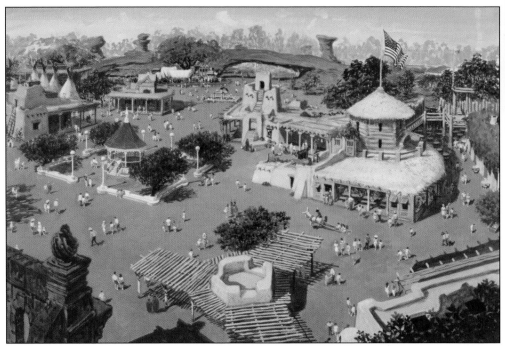

Early plans for Great America called for six themed areas, including the Great Southwest. Subsequently, development of the Great Southwest was deferred. This Duell rendering shows how planners envisioned an early concept of the southwest area. The park's 1977 expansion included the Southern Cross skyride that would provide transportation between Orleans Place and the future Great Southwest. At the new skyride's remote station, located in an empty field, a sign featuring YOSEMITE SAM™ proclaimed that the Great Southwest would rise there in 1979. The Great Southwest, however, was postponed and eventually never built by Marriott. Instead, Six Flags would add the Southwest Territory in 1996. (Courtesy of GREATAMERICAparks.com.)

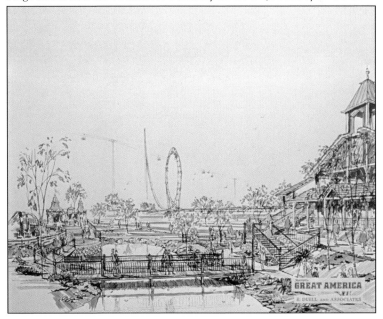

This Duell rendering of Yankee Harbor shows a design for the Tidal Wave roller coaster's site and station that differs significantly from what was actually built. Also visible in the drawing are the Lobster ride on the far left and the Southern Cross skyride crossing over the Tidal Wave. (Courtesy of California's Great America.)

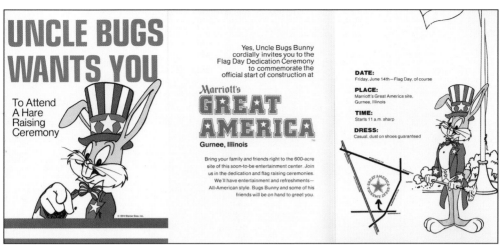

BUGS BUNNY was designated the official spokesrabbit of Marriott's Great America. As a nod to Uncle Sam, the patriotic rabbit from Brooklyn was sometimes called Uncle Bugs in his role as spokesrabbit. This is the official invitation from Uncle Bugs to the celebration marking the official start of construction of Marriott's Great America that took place on Flag Day, June 14, 1974. (Courtesy of California's Great America.)

For the ground-breaking and flag-raising ceremony, a crowd of an estimated 1,000 people eagerly gathered in a farm field on the site that was to become Marriott's Great America. This was the first show to be performed on the site. In addition to the entertainment that included BUGS BUNNY and other LOONEY TUNES characters, guests were treated to complimentary refreshments and balloons as they witnessed the official dedication ceremony. (Courtesy of GREATAMERICAparks.com.)

J.W. "Bill" Marriott Jr. presented a miniature railroad train engine to Gurnee mayor Richard Welton during the ceremony. The model train engine represented the train that would operate at Marriott's Great America. Seated at left is David L. Brown, head of Marriott's Theme Park Group. Earlier in the day, Marriott held a press conference in Chicago to announce details of the park plans. This included the presentation of artist renderings and descriptions of each of the park's five themed sections. (Courtesy of Kristopher D. Jones.)

Children enjoyed meeting Marriott's Great America's designer Randall Duell and official spokesrabbit BUGS BUNNY at the fun-filled event. (Courtesy of GREATAMERICAparks.com.)

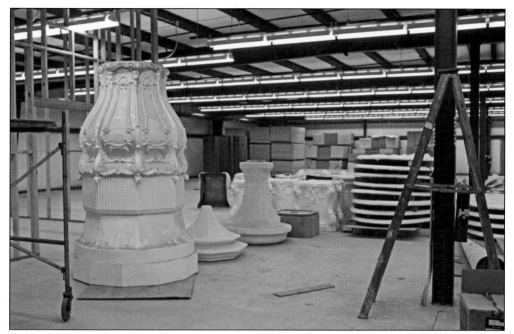

The monumental task of park construction soon was in full operation. A great deal of assembly took place inside the maintenance and warehouse buildings. Pieces of the grand Columbia Carousel are seen here before they were hauled outdoors for installation. (Courtesy of Kristopher D. Jones.)

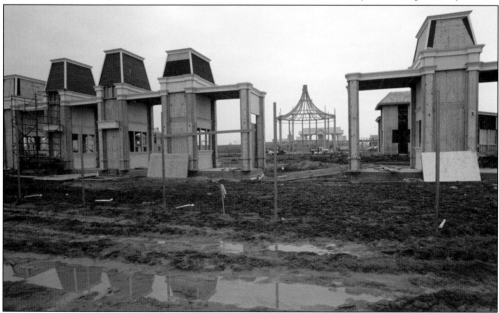

Construction of Marriott's Great America progressed no matter what conditions the weather brought. Whether the site was wet and muddy, covered in snow, or baked by the summer sun, the massive work effort went on. Seen here are the ticket booths taking shape amid the puddles and mud. The frame of the Columbia Carousel and the Hometown Square train station are visible in the distance. At the height of construction activity, workers numbered around 650. The first shift started each day at 5:00 a.m., and second shift ended at 10:00 p.m.

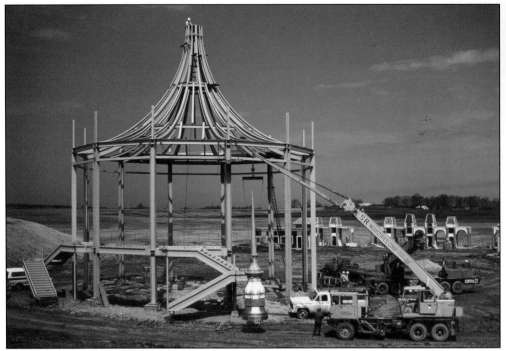

The majestic Columbia Carousel begins to make its mark on the Gurnee landscape. Here, the completed top spire of the carousel is delivered to the site. The larger crane nearby will be used to lift it into position atop the frame.

Pictured is Grand Avenue before the entrance road to Marriott's Great America had been constructed. Previously located here was Pine Street. The street and 12 houses were removed to make way for the six-lane vehicle entrance and exit that would serve the park. (Courtesy of Kristopher D. Jones.)

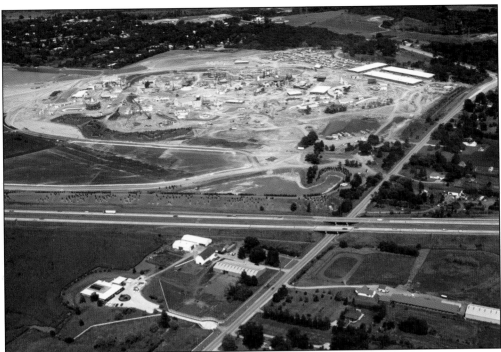

Marriott's 600 acres were split by the tollway, with the theme park located on the east side. In the foreground on the left is the former Ritter Farm. The farm's houses and buildings were used for early administrative offices, warehousing, and even a home for exotic animals for Marriott's Great America. At the far left on the farm property was a large home featuring an indoor swimming pool. Marriott covered the pool for use as office space. Except for one barn, these buildings were demolished. That barn was relocated near the park's greenhouses, where it still stands today. (Courtesy of Kristopher D. Jones.)

Painters here are finishing one of the ornate panels that will ring the top of the Columbia Carousel's structure. The incredibly detailed architectural sculpturing for the Columbia is the work of Chris Mueller Jr. These panels and other decorative components for the Columbia were formed in fiberglass using molds made from Mueller's original sculptures. Mueller's work also adorns buildings such as Cinderella's Castle at Walt Disney World. Also working in Hollywood, Mueller sculpted the monster's head for the famous film *Creature from the Black Lagoon.*

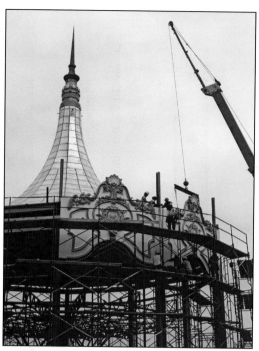

The second ornate panel has just been hoisted to the top of the Columbia Carousel's structure. Workers are seen here securing it into place. A total of 12 of these panels ring the top of the structure, providing a breathtakingly beautiful home for the fanciful double-deck carousel inside. The internals of the actual carousel ride mechanism are already seen here occupying the interior of the structure. (Courtesy of Kristopher D. Jones.)

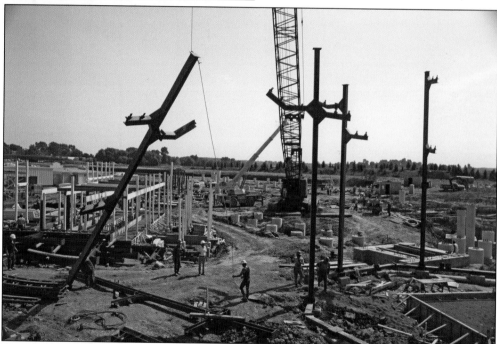

Construction begins on Willard's Whizzer, the roller coaster originally named in honor of J. Willard Marriott, founder of the Marriott Corporation. These columns are rising to eventually support the spiral lift that generations of Whizzer riders know so well. Also seen are a number of concrete footings that await the placement of supports for the coaster's track. At left, the Whizzer's station is seen in the early stages of construction. The Whizzer, manufactured by Anton Schwarzkopf of Germany, was known as a Speedracer roller coaster. (Courtesy of Kristopher D. Jones.)

Construction workers put finishing touches on the Whizzer. The center "third rail" on the track of the spiral lift will supply power to onboard motors to drive the coaster's trains to the top of the lift. Upon cresting the lift, the trains are powered solely by gravity as they travel the course of the track and return to the station. (Courtesy of Kristopher D. Jones.)

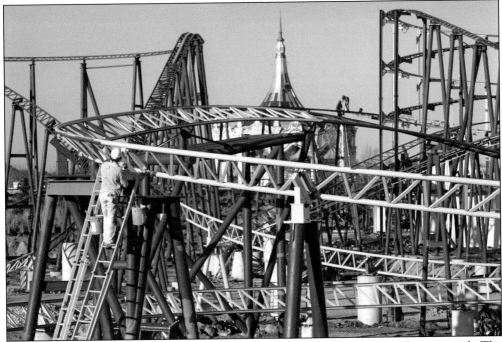

With the Whizzer's structure essentially complete, the roller coaster gets its first paint job. The original color of the Whizzer was a light green. (Courtesy of Kristopher D. Jones.)

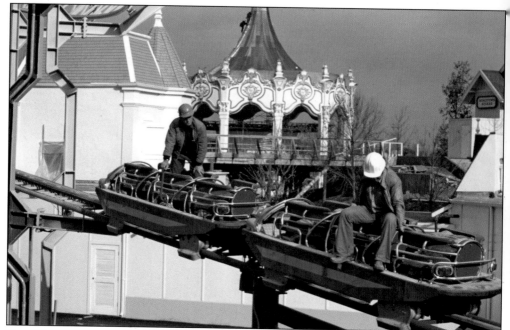

Two Whizzer cars are coupled and loaded with sandbags to provide weight. Two workers check out the cars before sending them out for a test run. All rides were subjected to extensive testing before being approved to take on human passengers for the first time. (Courtesy of Kristopher D. Jones.)

The Grand Music Hall is seen here under construction. Early documents refer to the Grand Music Hall as the Opera House. Located in Hometown Square, the Grand Music Hall was designed to be the signature entertainment venue at Marriott's Great America. Features of the theater included an orchestra pit and seating for 1,600. (Courtesy of Kristopher D. Jones.)

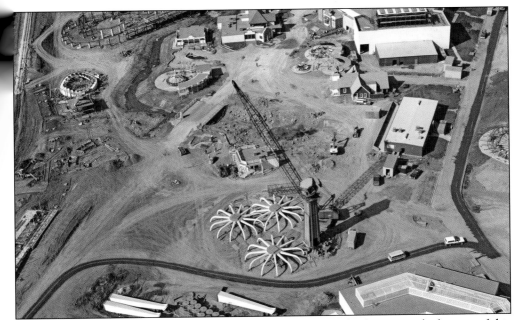

The parts needed to build the massive Sky Whirl triple Ferris wheel are near the bottom of this aerial view. At the upper left is part of the Whizzer's track. Other rides under construction, from left to right, include the Hilltopper, Bottoms Up, Hometown Square kiddie rides, and Yukon Yahoo. (Courtesy of Kristopher D. Jones.)

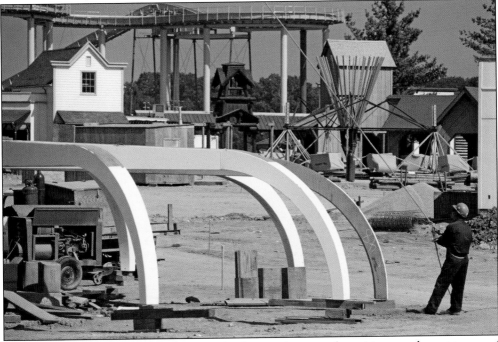

In County Fair, one of Sky Whirl's giant wheels is on the ground, awaiting attachment to one of the ride's three arms. In the background is Yukon Territory. On the right is the Saskatchewan Scrambler, which was later moved near the Whizzer and renamed as Hometown Fun Machine. In the far background is the upper flume of Yankee Clipper. (Courtesy of Kristopher D. Jones.)

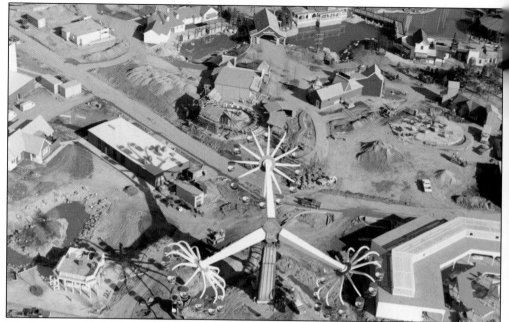

The fully assembled Sky Whirl is seen here. To its right is the Farmers Market food court, County Fair's largest food venue. A portion of Yukon Territory appears in the upper right, with the station for Logger's Run partially visible in the upper right corner. Along the rest of the top of the photograph is part of Yankee Harbor. The Hometown Square schoolhouse is partially visible at far left. (Courtesy of Kristopher D. Jones.)

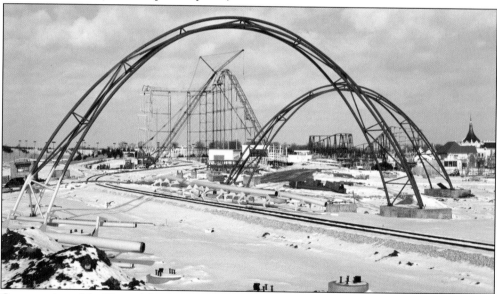

Construction of the Turn of the Century roller coaster in County Fair continues after a snowfall. Designed and manufactured by Arrow Development Company, the Turn of the Century was a custom, taller, longer, and faster version of the similar Chicago Loop roller coaster at the now defunct indoor Old Chicago amusement park in suburban Bolingbrook, southwest of Chicago. The two arches seen here would support the upside-down double corkscrew. (Courtesy of Kristopher D. Jones.)

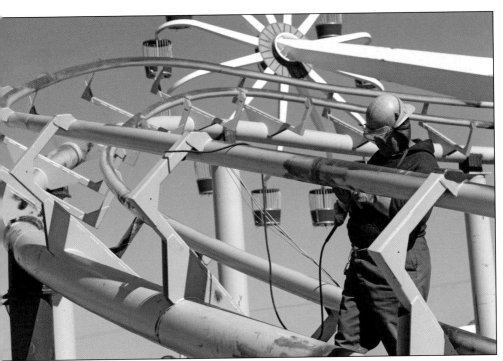

A worker smooths out a weld that joins two pieces of track for the Turn of the Century roller coaster. The Turn of the Century would later undergo a transformation that would change it into the Demon roller coaster. The Demon would make its debut in 1980. (Courtesy of Kristopher D. Jones.)

In County Fair, at the opposite end of the park from the Columbia Carousel, Marriott's Great America also featured an antique carousel known as the Ameri-Go-Round. Built around 1910 by the famed Dentzel Carousel Company, the Ameri-Go-Round originally operated at Fontaine Ferry Park in Louisville, Kentucky. Here, the Ameri-Go-Round is in the process of being reassembled. The sides of the new building housing the Ameri-Go-Round had been enclosed by sheets of plastic to protect the antique carousel from the elements. (Courtesy of Kristopher D. Jones.)

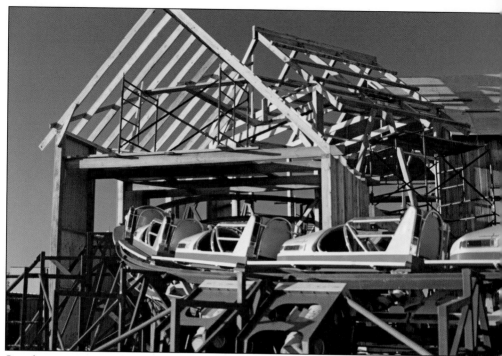

Seen here near completion, the Yukon Yahoo ride was created by Anton Schwarzkopf of Germany. The manufacturer's name for the ride is Bayern Kurve. The Yukon Yahoo provided a speedy trip around and around and up and down on a circular track. (Courtesy of Kristopher D. Jones.)

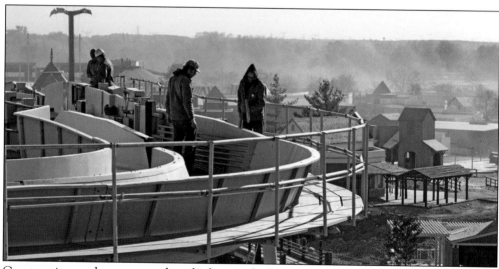

Construction workers are seen here high atop the Logger's Run flume ride at the approach to the flume's split into two side-by-side double-down chutes. Logger's Run and sister flume Yankee Clipper were designed and manufactured by Arrow Development Company. At the split, a swinging gate would direct alternating boats to each of Logger's Run's two chutes. This system was developed to increase ride capacity by enabling more boats per hour to traverse the course of the flume. Eventually, this approach was abandoned in favor of permanently closing one chute and exclusively using the other. (Courtesy of Kristopher D. Jones.)

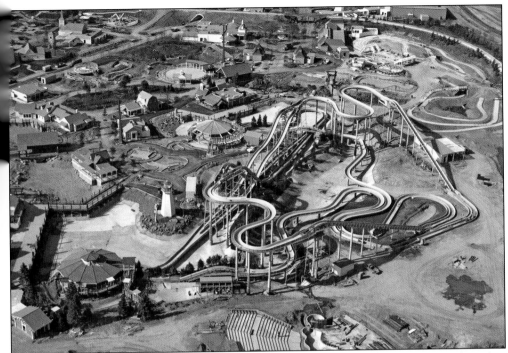

Marriott's Great America's two massive, interlocking flume rides, Logger's Run and Yankee Clipper, are seen here during park construction. In this image, nearly all of Yankee Harbor is visible. Portions of Yukon Territory are seen in the lower part of the photograph, including some of the Wilderness Theater at the lower center. Part of Orleans Place is in the upper right, while a little of Hometown Square can be seen in the upper left. (Courtesy of Kristopher D. Jones.)

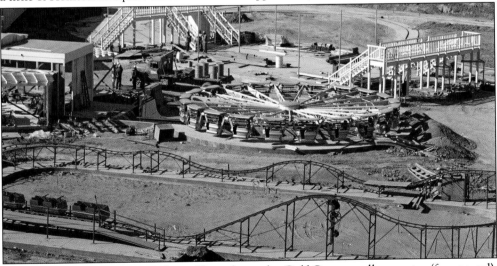

This construction scene in Orleans Place shows the Gulf Coaster roller coaster (foreground), which operated only for the 1976 season. It was replaced in 1977 by the station for the Southern Cross skyride. Beyond the coaster are the Orleans Orbit, an Enterprise ride from Schwarzkopf, and Traffique Jam, an antique car ride from Arrow Development Company featuring three unique tracks upon which guests could drive. This area is now occupied by Roaring Rapids, opened in 1984 as White Water Rampage. (Courtesy of Kristopher D. Jones.)

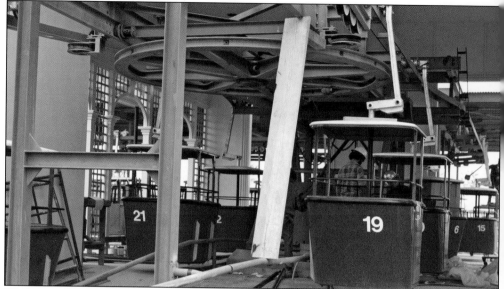

Workers are busy finishing up the Delta Flyer skyride in its Orleans Place station. In this photograph, the cable has yet to be installed as evidenced by its absence on the overhead horizontal bull wheel. The skyride provided transportation to and from County Fair, where the station was named Eagle's Flight. The Delta Flyer station served as the ride's tension station. A huge counterweight that was connected to the bull wheel via cables would pull on the bull wheel to keep the cable taut. The Delta Flyer/Eagle's Flight skyride was manufactured by Von Roll of Bern, Switzerland. (Courtesy of Kristopher D. Jones.)

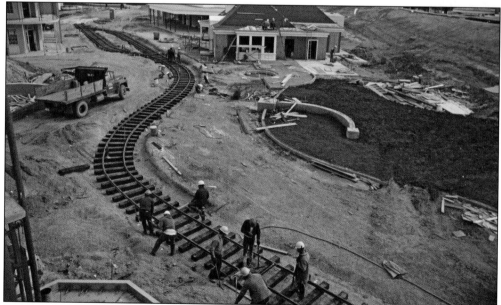

In this view from the upper level of the Columbia Carousel, one can see Orleans Place construction in progress. Workers are checking trolley track that has recently been laid. Later, the track ties would be covered by asphalt, leaving only the rails visible to park guests. The Hometown and Orleans Trolley would provide passenger service between the main squares of these two themed sections of the park. Parade floats would also travel on this track. (Courtesy of Kristopher D. Jones.)

Two

MARRIOTT'S
GREAT AMERICA

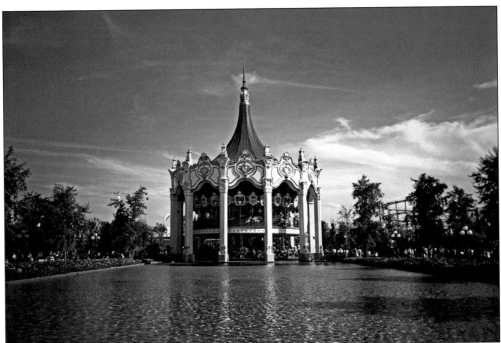

Marriott's Great America in Gurnee opened to the public for the first time on May 29, 1976. A nearly identical sister park in Santa Clara, California, also named Marriott's Great America, had opened a little more than two months earlier on March 20, 1976. Marriott's successful effort to build and open these two major parks at nearly the same time was an unprecedented achievement in the amusement industry. Visitors entering Marriott's Great America were greeted with this magnificent view of the Columbia Carousel and its reflecting pool. This grand entry area, separate from the park's themed areas, was named Carousel Plaza. (Photograph by author.)

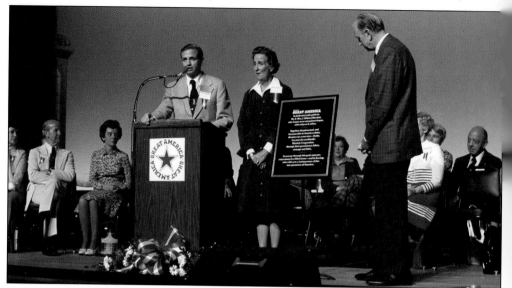

Dedication day was held on May 28, 1976. Activities included the premiere presentations of *Music! America!* in the Grand Music Hall, featuring the Great America Singers, and the Merry Mardi Gras Parade. Pictured here is J.W. "Bill" Marriott Jr. speaking during the ceremony in which the park was dedicated to his parents, Alice Marriott and J. Willard Marriott, founders of Marriott Corporation. On the stand is the dedication plaque that was installed at the front of the reflecting pool of the Columbia Carousel. Seated at the far right is Mel Blanc, famous for performing the voices of BUGS BUNNY and other LOONEY TUNES characters.

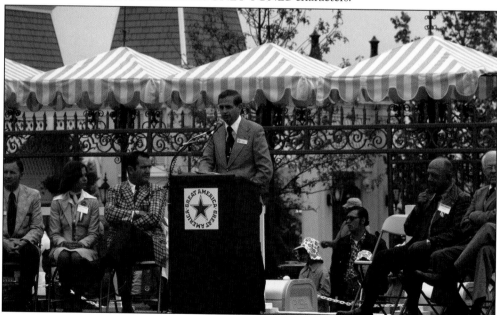

Bill Marriott speaks during the opening day ceremony on May 29, 1976, just inside the front gate on a podium set up at the front of the Columbia Carousel's reflecting pool. Seated from left to right are James Bouy, general manager of Marriott's Great America; Doreen Warvi, first lady of Marriott's Great America; Michael Hostage, vice president of Marriott Restaurant Operations; Mel Blanc, character voice actor; and Randall Duell, architect and designer of Marriott's Great America.

BUGS BUNNY joins the Marriotts for a photograph near the Columbia Carousel on opening day of Marriott's Great America. From left to right are J.W. "Bill" Marriott Jr.; Marriott's wife, Donna; Alice Marriott; and her husband, J. Willard Marriott.

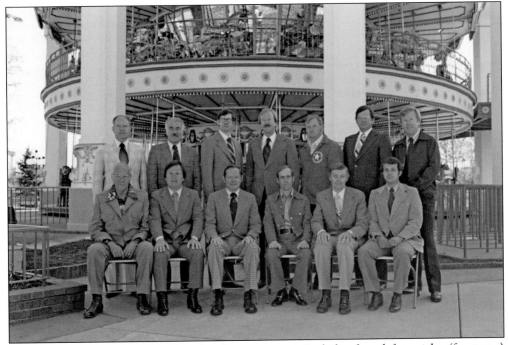

A group representing Marriott theme park management includes, from left to right, (front row) Truman Woodworth, general manager of Marriott's Great America, Santa Clara, California; Ron Johnson, assistant general manager, Marriott's Great America, Gurnee, Illinois; David L. Brown, vice president of theme park group; Gene Patrick, vice president of entertainment; Rolf Kennard, vice president of food operations; and Dennis Foland, vice president of merchandise and games; (back row) Bud Dreager, vice president of maintenance and construction; Dean Schallen, director of engineering; Joe Guzzo, vice president of finance; James Morrow, vice president of personnel; James Bouy, general manager of Marriott's Great America, Gurnee, Illinois; unidentified; and Sandy Quinn, vice president of marketing.

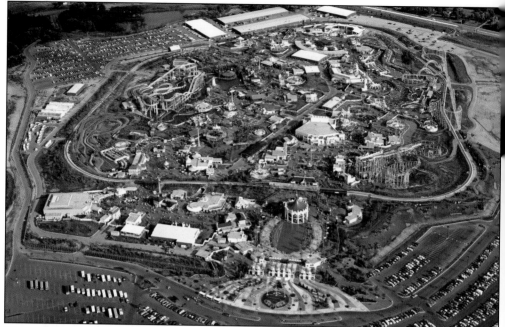

This aerial view from August 1976 shows how the park looked during its first summer. All of the original rides and attractions are here, from the Columbia Carousel in the front to the Grandstand Pavilion for the circus in the back and from the Logger's Run and Yankee Clipper flumes on the left to the Turn of the Century roller coaster at right. (Photograph by Scott D. Farrell.)

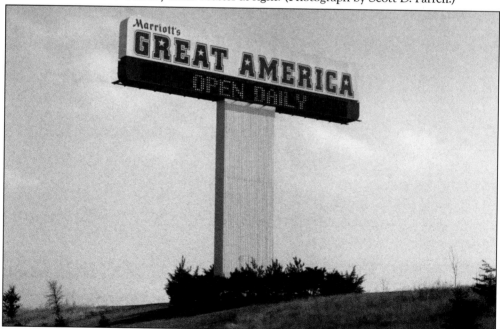

This sign next to the Tri-State Tollway was a familiar sight, welcoming visitors to the park year after year. The sign was installed for the 1977 season. Over the years, the sign has undergone multiple modifications. Portions of the original structure are part of the sign that still stands today. (Photograph by author.)

The Sky Trek Tower was added to Carousel Plaza as part of the park's 1977 expansion. The revolving passenger cabin lifts park guests to a height of 285 feet for stunning views of the entire park, as well as the surrounding region. On clear days, even the Chicago skyline can be seen from the tower. Sky Trek is known as a Gyro Tower, supplied by Intamin. The top of the flagpole is 330 feet above the base of the tower. The flag flown atop the tower measures 20 feet by 38 feet.

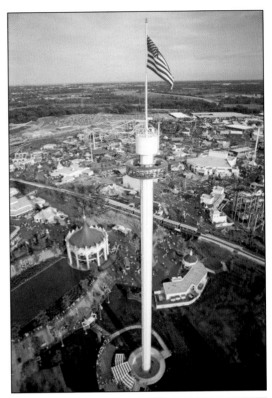

This is how the park looked from the Grand Avenue entrance during the early years. For children arriving in the family car, this sight filled them with great excitement. They had finally arrived and they knew that their day of incredible fun at Marriott's Great America was about to begin. (Courtesy of Kristopher D. Jones.)

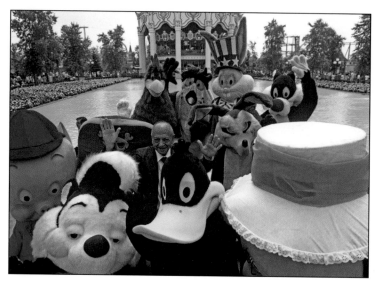

Legendary character voice actor Mel Blanc is seen here with a group of his LOONEY TUNES friends. Earning the nickname "The Man of a Thousand Voices," Blanc gave voice to these and other LOONEY TUNES characters. The LOONEY TUNES characters have been featured at the park every year since 1976. (Courtesy of Kristopher D. Jones.)

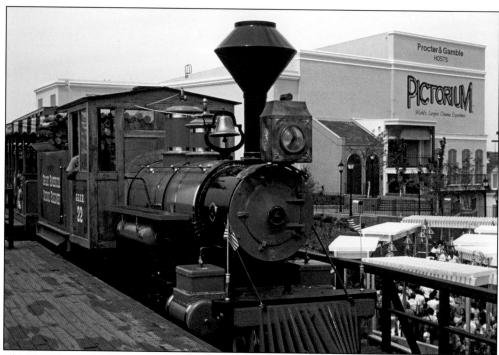

The Pictorium was added to Carousel Plaza in 1979. Seen here from the platform of the Hometown Square station of the Great America Scenic Railway, the Pictorium brought breathtaking IMAX films to Marriott's Great America audiences. The first film presented in the Pictorium was *To Fly*, from the National Air and Space Museum. For 1981, Marriott produced an IMAX film for the Pictorium called *An American Adventure*, directed by Timothy Galfas. An original 1976 attraction, the Great America Scenic Railway circles the park, providing transportation between Hometown Square and County Fair. The railway's two trains were built by Custom Fabricators of Johnson City, Tennessee. (Courtesy of California's Great America.)

The Hot Shoppe in Hometown Square was a replica of the Washington, DC, root beer shop opened by Alice and J. Willard Marriott in 1927. This "billion dollar root beer stand" was the humble beginning of the worldwide Marriott Corporation. The Hot Shoppe replica at Great America started out selling mugs of root beer for 5¢, the same price charged at the original Hot Shoppe. Over time, the price edged up. By the time of this photograph, the price had reached 25¢.

Opening in 1976, the Triple Play remains a Hometown Square favorite today. Triple Play was manufactured by Huss Maschinenfabrik of Bremen, Germany, whose name for the ride was Troika. The unique three-arm ride action of the Triple Play gives guests an exhilarating experience. (Courtesy of GREATAMERICAparks.com.)

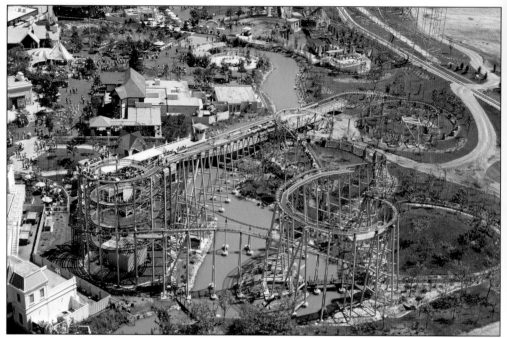

From Carousel Plaza's Sky Trek Tower, guests could easily see the entire layout of Hometown Square's Whizzer below. Eventually, the trees and other vegetation grew significantly and now hide much of the Whizzer's track from view.

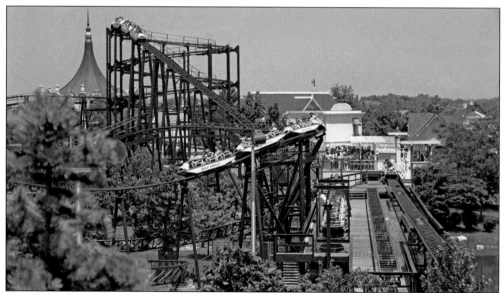

The Whizzer has consistently been a favorite of park guests since 1976. For many children, the Whizzer was their first big roller coaster, thus assuring its sentimental value. When the Whizzer was threatened with removal to make room for the SUPERMAN™: Ultimate Flight roller coaster, a massive "Save the Whizzer" public outcry erupted. The Whizzer remained and is the last of only four Schwarzkopf Speedracer roller coasters built in the United States. On August 10, 2012, the American Coaster Enthusiasts (ACE) designated the Whizzer as an ACE Roller Coaster Landmark for its historic significance.

Captain Kangaroo, portrayed by actor Bob Keeshan, appears perhaps a bit overwhelmed following a ride on the Whizzer. Four episodes of the *Captain Kangaroo* children's television show were filmed at Marriott's Great America in 1977. A variety of guest stars appeared in the shows from Gurnee, including Gale Gordon of *The Lucy Show*, John Ritter, Tom Smothers, and Bob Denver. In the seat ahead of Keeshan is Cosmo Allegretti, appearing in his role as Dennis the Apprentice.

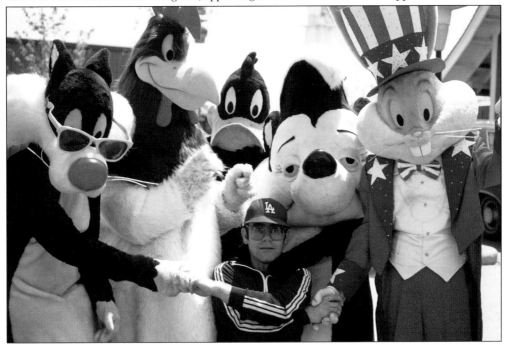

A young Elton John makes friends with the LOONEY TUNES characters during his July 23, 1976, visit to Marriott's Great America prior to performing in a series of concerts in Chicago. John and his entourage received VIP treatment as they toured the park. Some of the rides the star experienced were the Orleans Orbit, Logger's Run, and the Turn of the Century, which was reported to be his favorite. (Photograph by Scott D. Farrell.)

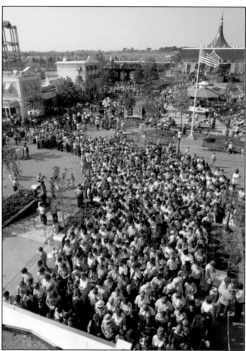

The live entertainment offerings at Marriott's Great America were planned to be just as compelling as the rides. In this 1976 view, throngs of guests eagerly await entry into the Grand Music Hall for a performance of *Music! America!*

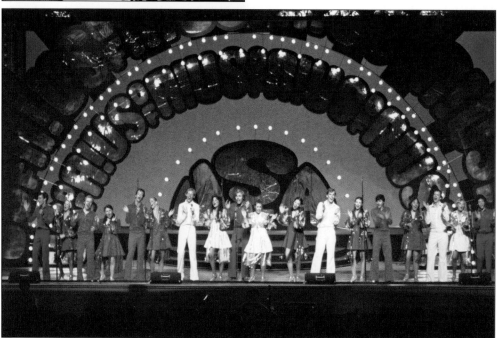

The Grand Music Hall was the signature show venue for Marriott's Great America. Its first production was *Music! America!* in 1976. The high-energy tribute to the music of America was considered to be a crowning achievement for the brand-new theme park. A live orchestra of 20 accompanied each performance's cast of 18 singers and dancers. A backstage crew of 10 kept it all going. Demand was so high that up to 10 shows a day were performed by two casts, a day cast and a night cast. (Photograph by Scott D. Farrell.)

The 1978 production in the Grand Music Hall was *Broadway*, a tribute to the great show tunes from Broadway musicals. Performing at Marriott's Great America was frequently the start of a successful entertainment career for many talented youths. For example, Liz Callaway, at far left, met with great success on Broadway, as well as providing the singing voices for many female characters in animated feature films.

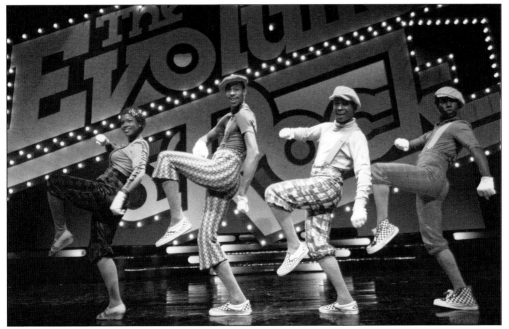

The Evolution of Rock came to the Grand Music Hall in 1983. The hit show is considered to be possibly the most popular in the park's history. *The Evolution of Rock* was of exceptional quality and audiences loved it. The show achieved attendance records and the highest levels of reported guest satisfaction. (Courtesy of David Carter.)

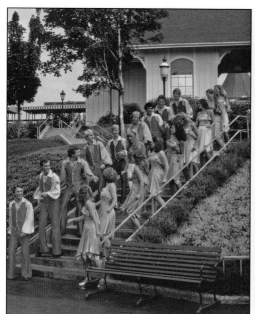

On the left, the Great America Singers took to the streets of Hometown Square to perform in this musical number with actress Lisa Hartman in 1979 for the WLS-TV special titled *You're Never Too Old*. On the right, outdoor entertainment in Hometown Square included this firehouse band. The firehouse ice-cream parlor also featured a singing quartet called the Flames. (Left, courtesy of Californa's Great America.)

Well-known Chicago radio personality Wally Phillips of WGN, seated between BUGS BUNNY and the cake, is seen here celebrating his birthday at Marriott's Great America. The park regularly attracted media attention with frequent visits by celebrities and Chicagoland media personalities. (Courtesy of Kristopher D. Jones.)

Budding television reporter Chris Von Seeger reports on the roller coasters of Marriott's Great America for *Kidsworld*, a syndicated television news magazine show that was reported for kids by kids. In his report, Von Seeger interviewed maintenance director John Hinde about technical aspects of the Whizzer, Turn of the Century, and Tidal Wave roller coasters. He also interviewed other kids for their comments about the coasters. The report included lots of great footage of the three roller coasters in operation.

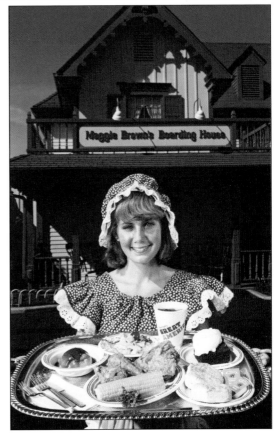

In a costume custom designed for the restaurant's hostess, a young lady presents a tray full of tasty offerings from Maggie Brown's Boarding House. Named in honor of David L. Brown's wife, Maggie, Maggie Brown's was the largest restaurant in Hometown Square. Maggie's specialty was delicious fried chicken with corn on the cob and biscuits. Maggie's apple dumplings were a favorite treat. Later known for many years as Aunt Martha's, in 2016 the restaurant was revamped with a new concept and renamed Strutters. (Photograph by Scott D. Farrell.)

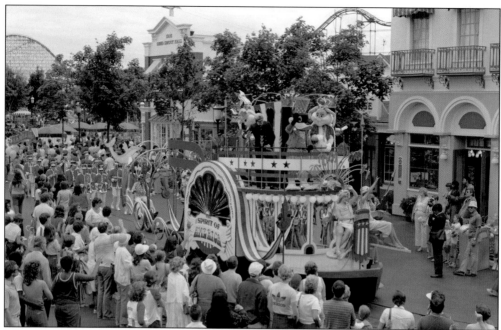

The Merry Mardi Gras Parade winds through Hometown Square on its way over to Orleans Place. This "Spirit of America" float was meant to represent Orleans Place. Each of the park's five themed areas had a representative float in the parade. Designed and built by Showcraft, Inc., of North Hollywood, California, the parade floats traveled on the trolley tracks.

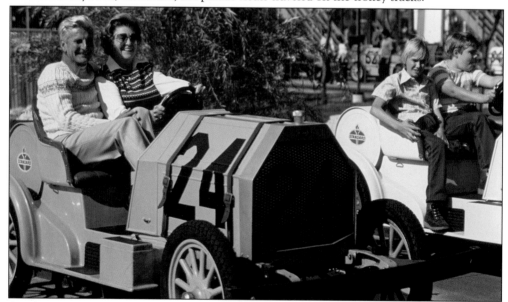

A major attraction in the park's County Fair section was the Barney Oldfield Speedway. Designed and built by Arrow Development, the speedway offered kids of all ages the opportunity to drive a real antique car. Originally sponsored by Amoco, also known as Standard Oil, the speedway consisted of three tracks in an elongated figure eight layout that included an overpass. The route was reconfigured later to accommodate Splashwater Falls. In 2012, X Flight took over the car ride's site. (Courtesy of GREATAMERICAparks.com.)

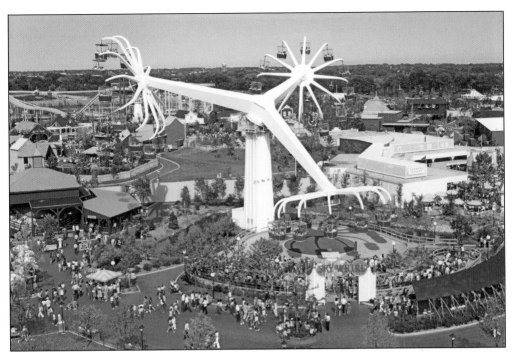

Sky Whirl was a massive triple Ferris wheel custom designed for Marriott's Great America. Manufactured by Waagner-Biro of Austria, Sky Whirl was sold by Intamin under the name Tree Triple Wheel. Two of the wheels would remain in constant motion high above the park while the third would land horizontally to allow for the simultaneous loading and unloading of its 12 six-passenger cabins. On the left is the Hay Baler, a Matterhorn ride from Mack Rides of Germany, added in 1977. On the right is the Farmers Market food court. A bit lower on the right is the covered walkway upon which vines would grow and provide shade. (Courtesy of GREATAMERICAparks.com.)

Sky Whirl did not have any decorative lights on the ride itself. Instead it was illuminated at night by clusters of spotlights. Here, the Sky Whirl is seen on a dark and foggy night just after it had been shut down for the park's closing time. (Photograph by Phill Greenwood.)

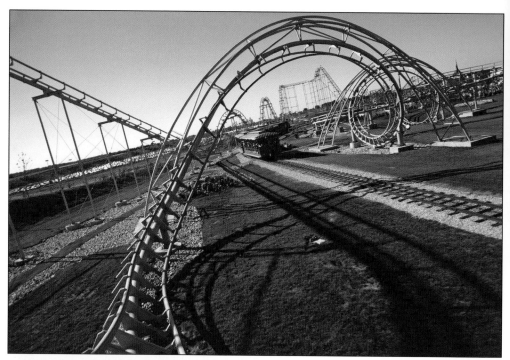

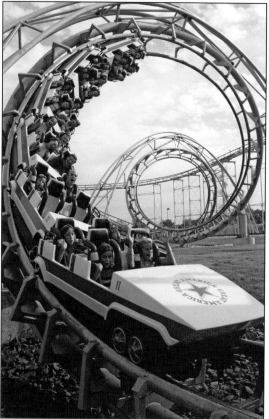

County Fair's most thrilling original attraction was the Turn of the Century roller coaster. Following a gut-wrenching first drop, the two innocent-looking smaller hills produced extreme "air time"—the sensation of flying out of one's seat—that left a lasting impression on many a rider. Pictured is a front-seat view as the coaster train makes its approach to the corkscrew. Taking riders head over heels twice, the corkscrew was the exciting finale to this hair-raising roller coaster ride.

The Turn of the Century's corkscrew was the ride's signature element. Prior to the introduction of the corkscrew on a similar but smaller roller coaster in 1975 at Knott's Berry Farm in Buena Park, California, roller coasters had not taken riders upside down since the generally unsuccessful attempts made in the 1800s and beginning of the 1900s. The Turn of the Century's corkscrew was the second in Illinois. A duplicate of the Knott's corkscrew roller coaster also opened in 1975 at the indoor Old Chicago amusement park in Bolingbrook.

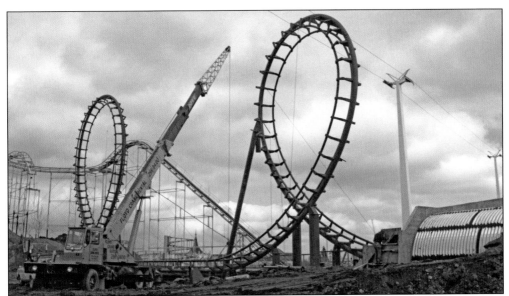

In 1980, the Turn of the Century was converted into the Demon. In 1976, Anton Schwarzkopf successfully introduced the modern vertical loop on a new coaster first called the Great American Revolution at what is now Six Flags Magic Mountain. Subsequently, roller coasters with vertical loops were built throughout the United States. Thrill-seekers seemingly could not get enough of the new roller coaster looping sensation. Schwarzkopf's 1978 Tidal Wave brought the first vertical loop to Gurnee. The Demon, however, would offer two consecutive vertical loops plus tunnels and special effects in addition to the existing corkscrew, taking riders upside down four times.

The Demon opened with an extensive theming package that included tunnels with fog and a light show, giant rock formations, a blood-red waterfall, special black and red caped costumes for the crew, a theme song, and more. The front car of each train was decorated with a large 3-D Demon logo. Teaser advertisements warned guests, "The Demon awaits you." For the grand opening, the chaplain of the Gurnee Fire Department performed a blessing on the Demon for the safety of all who were about to challenge this beast of a coaster. Those who braved the ride could proudly state, "The Demon spared me."

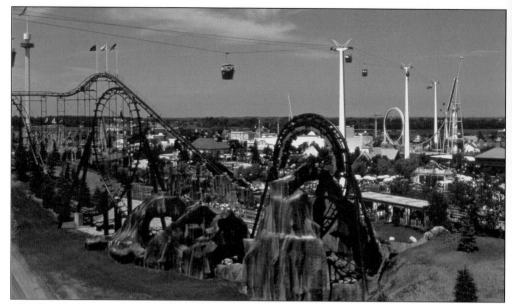

The Demon drew massive crowds. On busy days, all three trains ran on the track to move as many people through as possible. In this photograph, one train is starting up the lift hill, another is passing through the second vertical loop, and another is entering the station. All three vertical loops at Marriott's Great America are seen here. The Demon's two vertical loops are in the foreground, and the Tidal Wave's vertical loop is seen at right in the background. (Courtesy of GREATAMERICAparks.com.)

County Fair's major food venue was the Farmers Market, a theme park food court innovation. Guests could chow down on hot dogs, pizza, spaghetti, tacos, Swedish waffles, and more. A huge favorite was Andre's fresh-cut French fries. A bandstand provided live entertainment for guests as they dined.

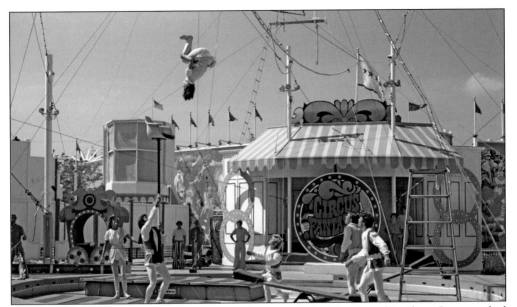

County Fair's major entertainment offering was the circus in the Grandstand Pavilion. Guests packed the stands for performances of the popular show. Named Colonel Cornfield's Centennial Circus in 1976, it became Circus Fantastic in 1977. The circus featured highly talented young performers who came to Marriott's Great America largely from the Sarasota Sailor Circus, Florida State University Flying High Circus, Illinois State University Gamma Phi Circus, and the Wenatchee Youth Circus. Many went on to successful circus and entertainment careers.

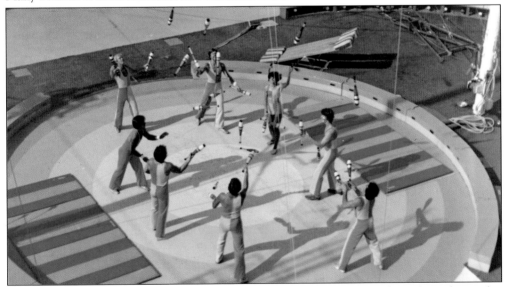

The technical prowess of Circus Fantastic performers is seen here in a rarely performed, complex trick. The normal version of a juggling pattern is for six clubs to be passed back and forth between two people. In this act, two people are passing six clubs, two more are passing seven clubs over the six, two more pass eight clubs over the seven, and two more pass nine clubs over the eight for a total of thirty clubs flying through the air! Three midair clubs were cropped out of the photograph. The two passing nine clubs, Dan Berg and Bruce Pfeffer, became the International Jugglers Association team champions the following year, 1979. (Courtesy of Dan Berg.)

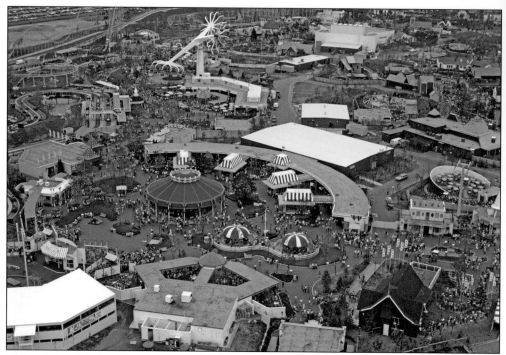

This 1976 aerial view above County Fair from the back of the park shows large crowds entering the Grandstand Pavilion for a circus performance. On a typical busy day like this, large numbers of guests filled the park. A full queue at the Eagle's Flight skyride extends well out into the street in the lower right corner. Queues were full at every ride, shows were filled to capacity, and food venues were packed. Marriott would address this by increasing park capacity with aggressive expansion plans for each of the next several years. (Courtesy of Phill Greenwood.)

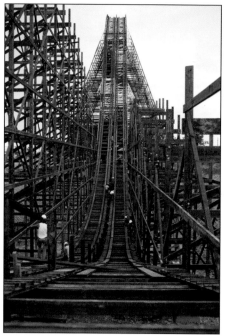

The biggest Marriott expansion project at the park was the American Eagle, a double-racing wooden roller coaster. Construction on the American Eagle began in the summer of 1980 in anticipation of a May 1981 opening. The American Eagle would be the tallest and fastest racing wooden roller coaster in the world to date. The lift hill would rise 127 feet above Marriott's Great America. The first drop, however, would measure 147 feet in height thanks to the excavation of earth 20 feet below ground level, extending the overall height for the descent. The full height of the first drop is seen here with the American Eagle's construction well under way.

Angie Lovell, first lady of Marriott's Great America, climbed to the top of the American Eagle's lift hill in a dress and high heels for this photograph with Jim Figley by park photographer Jerry Moore. Construction of the American Eagle was the job of Figley-Wright Contractors for Intamin. Bleck & Bleck Architects, then of Waukegan and now Libertyville, was responsible for designing the American Eagle's station and ride lighting, converting the Grandstand Pavilion into the queue area, and more. American Eagle was Bleck & Bleck's 12th project at the park. In addition to restaurant and retail projects, the firm has worked on most major rides added after the Eagle. THE JOKER™, new for 2017, is the firm's 241st project at the park.

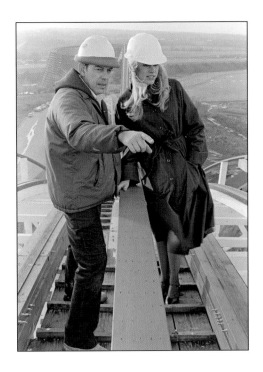

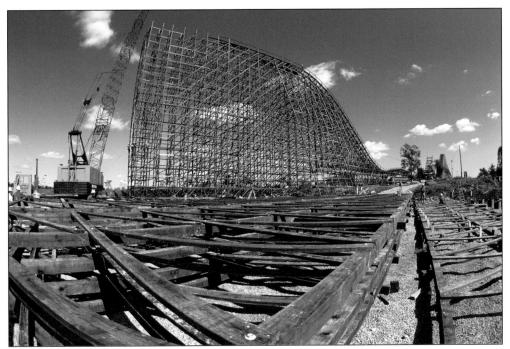

Construction of the American Eagle was a massive project that required a mind-boggling amount of wood and other materials. The vertical structural elements of a wooden roller coaster are called bents. Pictured here are newly assembled gigantic bents on the ground that will be raised and placed into position by crane. The portion of the coaster under construction here is the approach to what will be the giant helix.

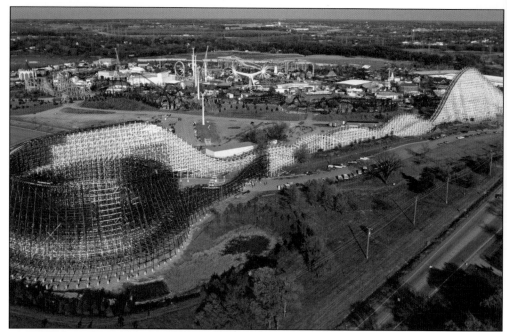

The American Eagle was the largest single investment in Marriott's Great America since the original construction of the park. With construction of the American Eagle nearing completion, this aerial view gives a sense of how enormous the American Eagle would be in relation to the rest of the park.

Opening day for the American Eagle came on Saturday, May 23, 1981. Marching bands and special guests were on hand for the opening celebration. Following the ceremonial ribbon cutting, Richard E. "Dick" Marriott joined one of his daughters in the front row of the blue side for the American Eagle's official inaugural ride.

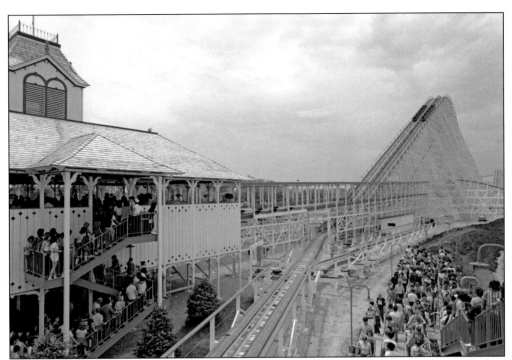

In this opening day photograph, park guests eagerly await their turns to experience the American Eagle. Meanwhile, blue and red trains head up the lift hill side by side, ready for a race. The red train typically gains an advantage on the inside of the helix. However, the track was designed to even out, with both sides each being 4,650 feet long.

The American Eagle is a beautiful ride that was a proud achievement for Marriott's Great America. During construction, the park created a great deal of buzz about the epic project by refusing to confirm or deny that the huge structure rising above the park was a new roller coaster. The working name for the coaster had been Boot Hill. The truth about the new coaster was revealed when the American Eagle was announced to the press on October 15, 1980, in Milwaukee and on October 16 and 17, respectively, in Chicago and Rockford.

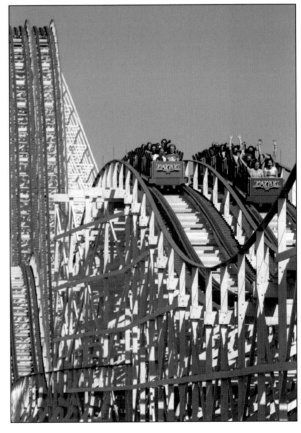

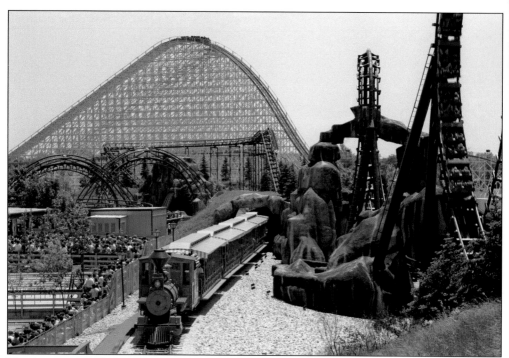

The American Eagle significantly changed the skyline of Marriott's Great America. Like these other County Fair rides—the Demon and the train—the American Eagle has become a true classic.

The first skyride at Marriott's Great America was named Eagle's Flight in County Fair at the back of the park and Delta Flyer in Orleans Place at the front of the park. Marriott's Great America reported that Delta Flyer/Eagle's Flight had been the most popular ride during the park's first year, having given rides to 1,818,815 guests. This station was converted into the Funnel Cake Foundry following the skyride's removal after the 1984 season. The Delta Flyer station once stood in the area where Condor is located next to the Rue Le Dodge bumper cars. (Photograph by author.)

One of the lesser-known rides in the park's history was the traditional Ferris wheel. It was added for the 1980 season. The Ferris wheel was located between the Eagle's Flight station and the Fairgrounds Junction train station. The Eli Bridge Company of Jacksonville, Illinois—west of Springfield in central Illinois—manufactured the Ferris wheel.

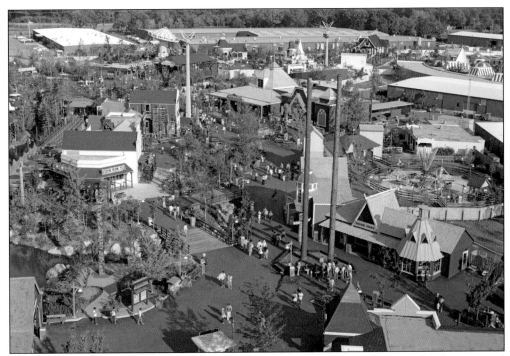

This is an overview of a major portion of the original Yukon Territory. The two tall poles were used for the pole-climbing contests performed by experts for park guests to observe. On the right is the Saskatchewan Scrambler, which was later moved to Hometown Square and is known as the Hometown Fun Machine. Fort Fun occupied this space and more when it was built for the 1978 season. Near the upper left of the image, the Whirligig is visible at its original location in the park.

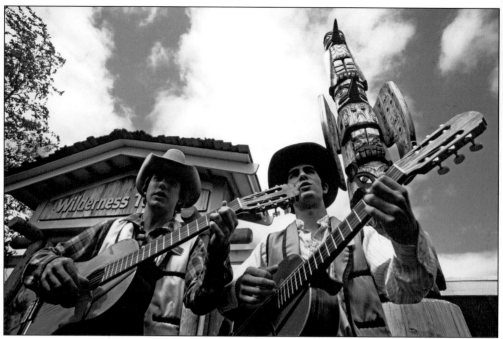

Marriott's Great America was designed to have entertainment everywhere. These two roving musicians could be found performing for guests throughout Yukon Territory. They are seen here outside the Wilderness Theater, next to one of the park's beautiful totem poles. The poles were expertly crafted by truck driver turned master totem pole wood-carver George Gulli. Gulli was hired by Marriott to carve the totem poles and other wooden creations for both the Santa Clara, California, and Gurnee parks. He did his carving at the Santa Clara park.

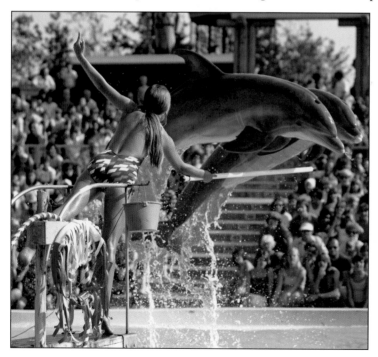

Audiences enjoyed the antics and graceful acrobatic feats of the dolphin pair Nemo and Neptune. The dolphins were a highlight of the animal-themed shows that were performed in the 2,500-seat Wilderness Theater. The dolphins were trained and supplied by Quinlan Marine Attractions for Marriott's Great America. Nemo and Neptune were flown in from Quinlan's training facility in North Carolina. (Photograph by Scott D. Farrell.)

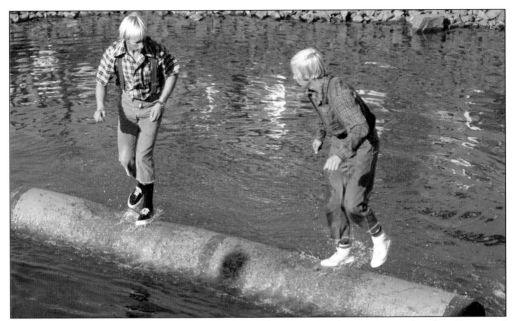

Entertainment in Yukon Territory included logrolling contests featuring twin brothers Rene and Raymond Scott. They are real-life lumberjacks from Nova Scotia whose family still operates one of the oldest small family mills in North America. One or both logrollers, known as birlers, would eventually end up in the water, getting soaked much more thoroughly than the guests riding nearby Logger's Run. (Photograph by Scott D. Farrell.)

Opened in 1978, Fort Fun was the biggest and most innovative play area many children had ever experienced. They could climb on nets, punch their way through a forest of padded bags, roll in the ball crawl, soar on kid-sized zip lines, explore an upside-down house, and much more. In other words, it was a great place for kids to have fun.

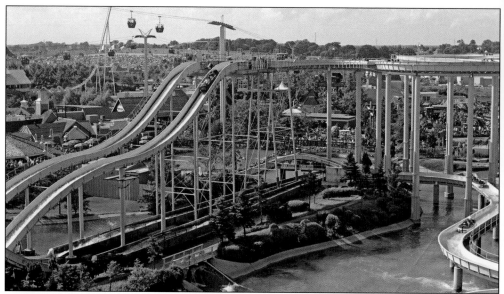

Logger's Run and Yankee Clipper, the huge interlocking flume rides, afford guests a fun and thrilling ride plus some refreshing relief from the summer heat with a cool splashdown finale. These high-capacity rides were among the park's most popular before the addition of any other water rides or attractions. Logger's Run's double-down chutes are a unique feature rarely found on any other flume ride. (Photograph by author.)

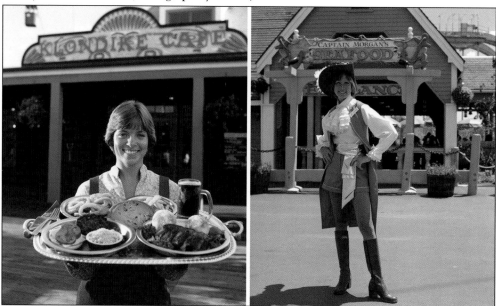

Klondike Café, with the attached Snowshoe Saloon, was the major restaurant in Yukon Territory. The menu included themed food items similar to what miners would have eaten along with more traditional favorites. Food was served on miners' pans and metal eating utensils were provided. A highlight of the entertainment in the Snowshoe Saloon was a musical revue featuring can-can dancers. Meanwhile, in Yankee Harbor, Captain Morgan's Sea Food was the main restaurant. Captain Morgan herself is seen in the costume designed especially for her appearance at the restaurant. (Left, photograph by Scott D. Farrell.)

Instead of logs, park guests travel in small clipper boats on the Yankee Clipper flume. The thrilling 60-foot drop was too scary for many when the ride was new. Yankee Clipper is a type of flume from Arrow Development known as a hydroflume. At the bottom of the big drop down the chute, boats speed over a slight rise, which is a distinguishing feature of a hydroflume. (Photograph by author.)

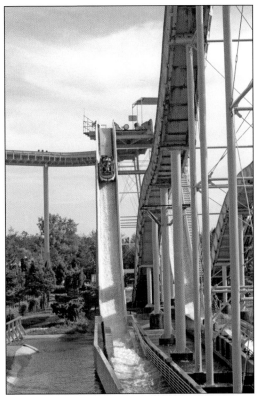

Operating only for the 1976 and 1977 seasons, the Spinnaker in Yankee Harbor is a largely forgotten, long-gone ride. Manufactured by Frank Hrubetz and Company of Oregon, the Spinnaker was known as a Super Round Up ride. The Spinnaker's site was given over to the Tidal Wave roller coaster. The wooden poles and netting that decorated the entrance to the Spinnaker were kept for the entrance to the Tidal Wave. (Photograph by Scott D. Farrell.)

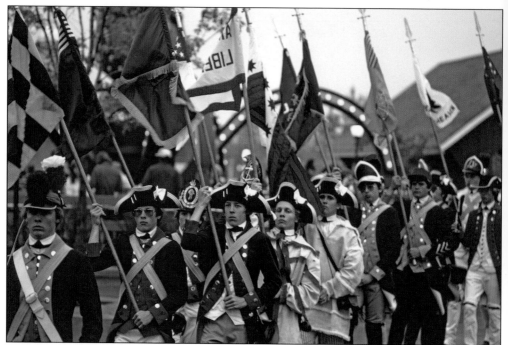

With the proposed American Heritage Theater never built, Yankee Harbor was the only themed section of the park to open without a dedicated show venue. Therefore, the most significant entertainment offering in Yankee Harbor was the parades and drills performed by the Continental Militia, also called the Colonials. Thanks to rigorous, in-depth research by noted circus historian Mel Miller, the group was outfitted in faithful replicas of the original uniforms and carried the battle flags, many nearly lost to history, of the militias of the original 13 states.

The Lobster in Yankee Harbor was manufactured by Anton Schwarzkopf of Germany. His company's name for the ride was Monster III. With five cars on five arms, the Lobster took guests on a fast, whirling adventure. The ride still operates at the park. The name was changed to East River Crawler in 1992 with the introduction of the BATMAN: The Ride roller coaster. Seen here enjoying a ride on the Lobster are actress Cloris Leachman and her daughter Dinah. The actress, who was appearing in a comedy at the theater at Marriott's Lincolnshire Resort, was a special guest for opening day of the 1978 season. (Courtesy of Kristopher D. Jones.)

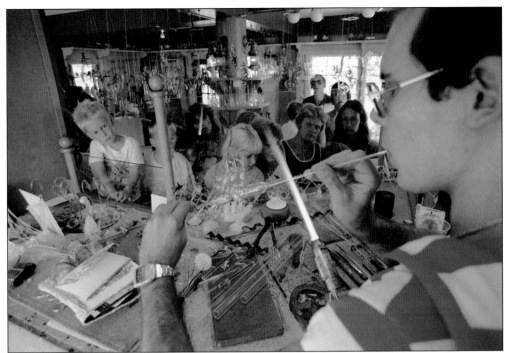

Fascinated guests watch a glassblower make exquisite items out of molten glass in a Yankee Harbor shop. Marriott's Great America presented shopping as part of the show by employing one of the largest numbers of skilled craftspeople among theme parks anywhere in the country. They demonstrated their skills in shops throughout the park, offering their creations for sale. Shops were designed for showmanship and merchandise presentation with furniture and fixtures in keeping with each themed area. Even merchandise offerings were related to each section's theme. The most popular souvenir items were custom designed, featuring the LOONEY TUNES characters.

Accompanied by First Lady of Great America Robin Foster, actor John Ritter pauses for a snapshot in Yankee Harbor during the filming of an episode of the *Captain Kangaroo* television show in 1977. Ritter was one of many guest stars who visited Marriott's Great America for the filming of four *Captain Kangaroo* episodes.

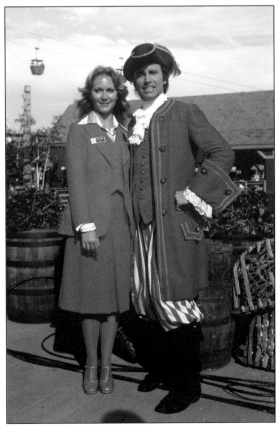

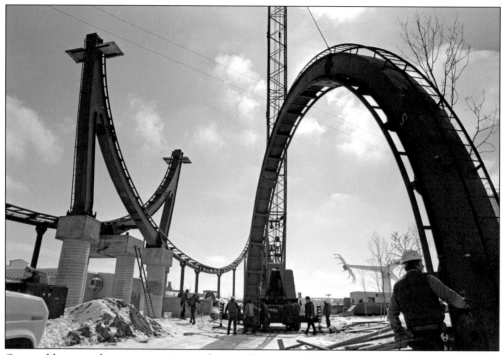

On a cold winter day, construction workers are busy assembling a new wave of excitement that would launch at Marriott's Great America in 1978. Another of many rides at the park manufactured by Anton Schwarzkopf of Germany, this would be known as the Tidal Wave, a shuttle loop roller coaster. The Tidal Wave's coaster train would shuttle forwards and backwards through the loop. The innovative coaster actually utilized the dropping of a huge counterweight to catapult the train through the loop and up the 142-foot incline. The train would then fall back and speed through the loop backwards on the return trip to the station.

Well-known Chicago radio personality John "Records" Landecker of WLS was the official first rider of the Tidal Wave. He was on hand for the ride's grand opening in May 1978. To honor him for being the first official rider, a plaque was displayed in the Tidal Wave's station. Landecker also did his show in live remote broadcasts from Great America during special promotions, such as WLS date nights. (Photograph by Scott D. Farrell.)

The Southern Cross skyride afforded guests great views of the Tidal Wave, such as this one. It carried riders right over the Tidal Wave between the loop and the highest point of the track where the train reversed direction. (Photograph by author.)

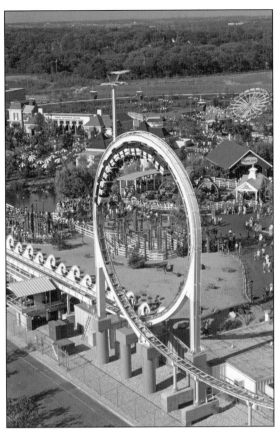

Davey Jones Dinghies, an Intamin Flying Dutchman ride, was added to Yankee Harbor as part of the park's 1977 expansion. Making efficient use of space, the dinghies ride was situated on a concrete pedestal located within the tracks of the Traffique Jam antique car ride. A similar pedestal was built within the tracks of the Barney Oldfield Speedway that same year as the home to the new Big Top ride. That pedestal still remains and is used for the Dare Devil Dive Sky Coaster attraction. The building seen behind the dinghies is the station of the Southern Cross skyride. (Courtesy of GREATAMERICAparks.com.)

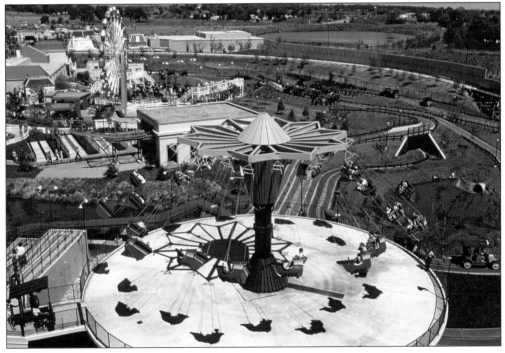

Crossing the covered bridge from Yankee Harbor into Orleans Place, the first attraction on the left would have been the Cajun Cliffhanger, a rotor ride from Chance Manufacturing in which the floor dropped down in a spinning barrel, leaving guests plastered to the wall. And on the right would have been David's Le Bumpe (pictured). Named in honor of Bill Marriott's son David, it was a miniature version of the full-sized bumper car ride Rue Le Dodge. Here, the younger set could enjoy bumper car fun at a scale better suited to their size.

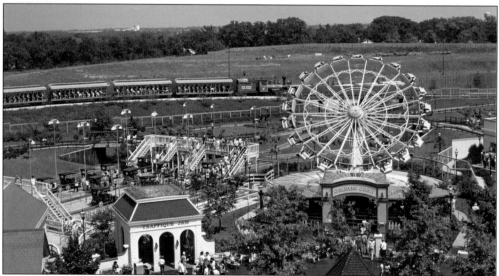

The Orleans Orbit was another ride from Anton Schwarzkopf's factory in Germany. The wheel carrying 21 passenger gondolas starts out at rest in a horizontal position at ground level for easy loading and unloading. The wheel spins and a large arm lifts the wheel to an upright position, turning riders completely upside down at the top. Relocated to Hometown Square to make way for 1984's White Water Rampage ride, the Orbit took its last spin in the park late in the 2016 season. Also seen here is Traffique Jam, one of two antique car rides at Marriott's Great America. (Courtesy of Phill Greenwood.)

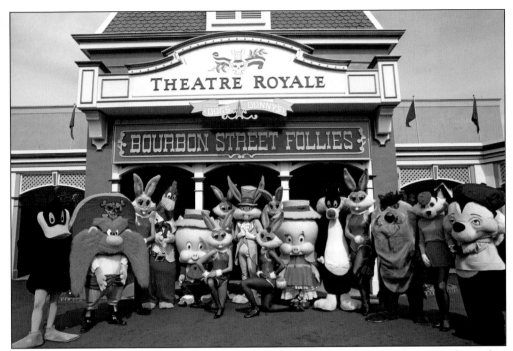

Theatre Royale was a 1,000-seat show venue in Orleans Place. It was the home to shows that featured BUGS BUNNY and the LOONEY TUNES characters. While the shows were intended to entertain children, they were designed to be enjoyable for adults as well. Seen here, the cast of 1977's *BOURBON STREET FOLLIES*™ has assembled for a group photograph outside the theater. (Courtesy of Kristopher D. Jones.)

The year 1982 brought *BUGS BUNNY'S LAS VEGAS REVUE*™ and a taste of Las Vegas to Theatre Royale. The show featured dazzling lights, beautiful sets, glamorous costumes, songs and dance, and plenty of laughs thanks to characters such as Daffy Davis Jr., portrayed by DAFFY DUCK™. (Courtesy of Phill Greenwood.)

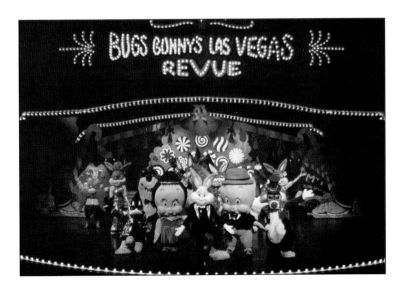

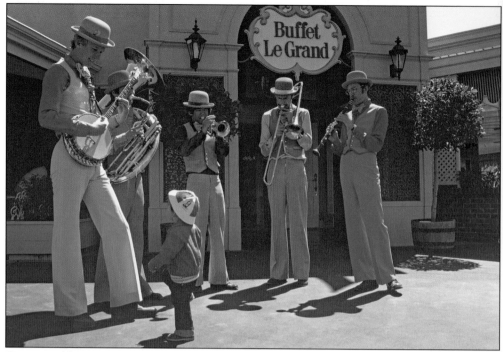

Guests could encounter entertainment opportunities at every turn in Marriott's Great America. Here, a young visitor appears to be fascinated with a performance by a jazz band in Orleans Place, just outside of Buffet Le Grand.

Buffet Le Grand was the signature restaurant in Orleans Place. It was intended to be the finest dining experience at Marriott's Great America. The menu featured many New Orleans favorites and tempting desserts. (Courtesy of Kristopher D. Jones.)

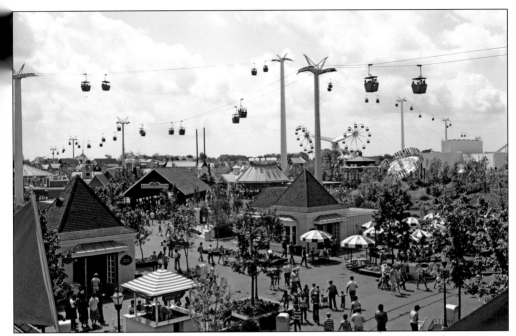

This section of Orleans Place is known as Mardi Gras today. Orleans Place was home to two skyride stations. The 1976 Delta Flyer provided transportation to County Fair from the front of the park to the back. The 1977 Southern Cross provided a round-trip-only aerial tour of Marriott's Great America. It was intended to eventually provide transportation between Orleans Place and the Great Southwest. (Courtesy of Kristopher D. Jones.)

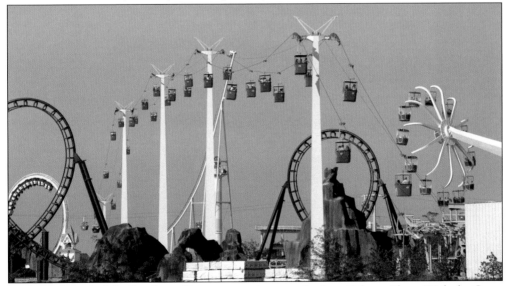

From the far end of the Southern Cross, it was a long way back to Orleans Place. With the Great Southwest still undeveloped, the unadorned "south end" station of the Southern Cross served as simply a turnaround point in an empty field. Skyride cabins filled with guests would arrive just to be sent back on their return trip to Orleans Place. In this 1980 photograph, the large stacks in the lower center are bundles of lumber for the American Eagle's construction. (Photograph by author.)

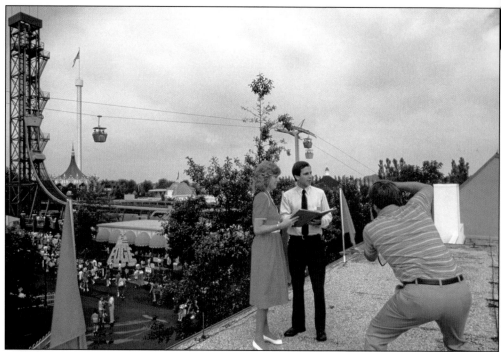

The Edge, loosely themed around WILE E. COYOTE™ and the ROAD RUNNER™, was an Intamin Free Fall ride. Opened in 1983, it was located in Orleans Place. Four-passenger cars were lifted to the top of the 131-foot-tall tower then released for a pure free fall of 99 feet, including the curve at the bottom of the drop. Director of personnel Marcia Britton and director of park operations Mike Newton introduced the new ride to the press from this Orleans Place rooftop. (Courtesy of Phill Greenwood.)

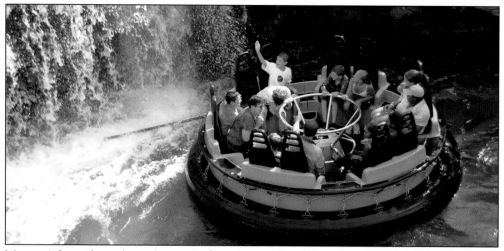

Marriott's last ride in the park was the $5 million White Water Rampage that opened in 1984. Improving on features of earlier rapids rides, White Water Rampage was the first rapids ride to use the rotating turntable loading platform for increased capacity. Plans called for authentic wilderness landscaping with more than 1,400 trees, shrubs, grasses, and wildflowers to be planted. In addition to the wild rapids, the ride included waterfalls and a 120-foot-long tunnel filled with special effects. After 1988, the name was changed to Roaring Rapids. (Photograph by Kyle Smith.)

Three

SIX FLAGS
GREAT AMERICA

In May 1984, Six Flags acquired Marriott's Great America as a result of Marriott Corporation's decision to exit the theme park business in favor of concentrating on its core hotel business. Thus, Marriott's Great America was welcomed into the Six Flags family of theme parks and became Six Flags Great America. The classic Six Flags logo was substituted for "Marriott's" in the park's logo as seen here on the Grand Avenue entrance sign. At the time, Six Flags was owned by Bally Manufacturing Corporation of Chicago.

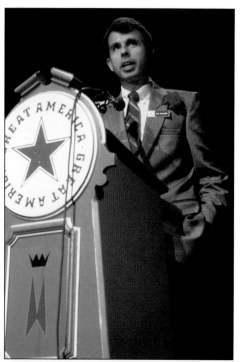

On April 26, 1984 at a meeting of full-time employees in the Pictorium, Ron Johnson, group vice president for theme parks, announced that Marriott's Great America in Gurnee would be sold to Bally Manufacturing Corporation. Steve West of Marriott's legal department and Dan Howells, president of Six Flags Corporation, a division of Bally, also spoke. At a subsequent transition meeting in the Grand Music Hall, Ray Williams, the park's first Six Flags general manager, is seen here speaking to park employees. (Courtesy of Phill Greenwood.)

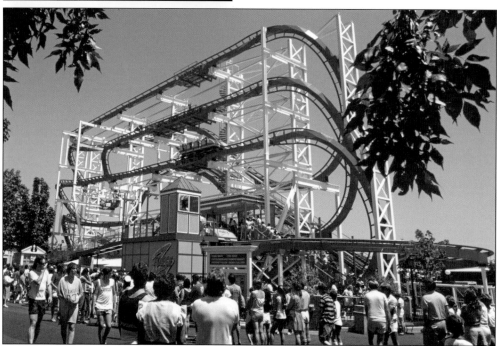

Z-Force was the first ride that Six Flags added to Great America. Manufactured by Giovanola for Intamin, the unique ride was known as a Space Diver roller coaster. Located in County Fair, Z-Force opened in 1985 and operated at the park through 1987. It was subsequently sent to Six Flags Over Georgia and later to Six Flags Magic Mountain. The Z-Force station was remodeled and reused for Iron Wolf and later for Goliath.

Z-Force thrilled its riders by plunging them down a sequence of extremely twisted and steep curving drops. Multiple levels of flat track sections connected the twisting drops. The coaster, with its unusual appearance, was like no other. It was the only Space Diver ever produced.

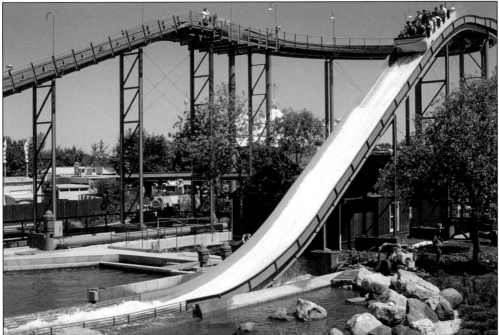

Six Flags' second ride addition to Great America also went into County Fair. For 1986, the Splashwater Falls shoot-the-chutes ride by O.D. Hopkins was built in the center of the Great America Raceway. The raceway, originally named the Barney Oldfield Speedway, had its course modified to accommodate Splashwater Falls. The new ride carried guests up to a height of 50 feet before plunging them back down, causing a massive splash that soaked both riders and spectators standing on a bridge over the waterway.

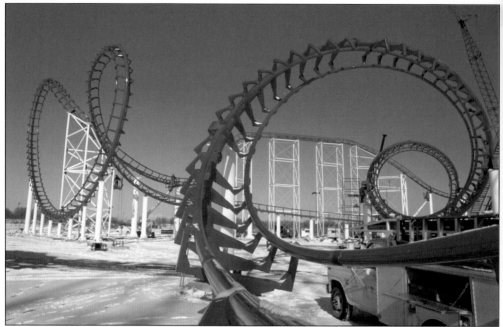

Six Flags continued to invest in Great America each year, adding Power Dive, an Intamin Looping Starship ride, to Orleans Place for 1987. Orleans Place would also be home to a much bigger addition for 1988: Shock Wave from Arrow Dynamics, formerly Arrow Development. Seen here while under construction, the Shock Wave was a big brother to the Demon.

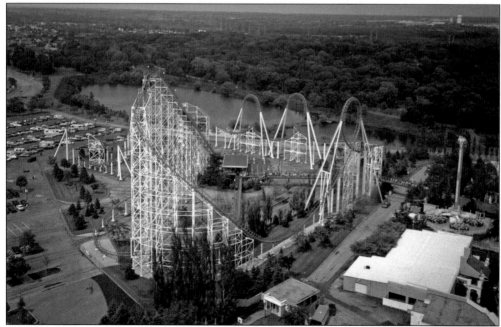

Standing 170 feet tall, Shock Wave dominated the park's skyline. The twisting 155-foot drop sent riders on a high-speed, dizzying journey that would turn them upside down seven times before returning them to the station. This is the familiar view of Shock Wave from the Sky Trek Tower. (Photograph by author.)

Shock Wave's first loop towered above Orleans Place. Also seen in this view is 1991's Condor ride manufactured by Huss of Bremen, Germany. The building at left is Rue Le Dodge, a 1976 original bumper car ride. Shock Wave's last run would be in 2002. It vacated its location to make way for 2003's SUPERMAN: Ultimate Flight. (Photograph by Mark Rosenzweig.)

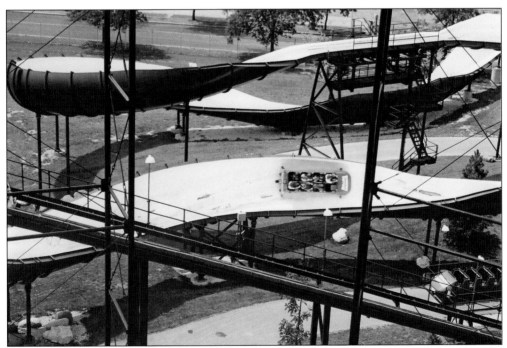

The Rolling Thunder bobsled coaster joined Great America's ride lineup in 1989. Originally opened at Six Flags Great Adventure in New Jersey, the ride was manufactured for Intamin by Giovanola. Rolling Thunder afforded riders a thrilling bobsled-like adventure in cars that sped down an open trough rather than on a fixed-rail track. After the 1995 season, Rolling Thunder moved from Great America to Great Escape, a Six Flags theme park in Lake George, New York. It can be found still operating there today. (Courtesy of Todd Doerge.)

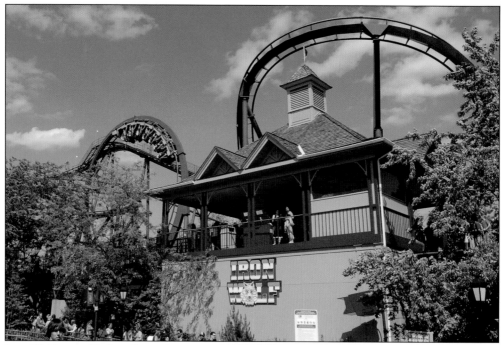

Iron Wolf was added to Great America in 1990. Of historical significance, it was the first roller coaster from the firm Bolliger & Mabillard, also known as just B&M. The company was founded by Walter Bolliger and Claude Mabillard, two Giovanola alumni who had worked on Z-Force as one of their Giovanola projects. Iron Wolf offered riders the opportunity to ride a roller coaster in a standing position rather than seated. (Photograph by Johnny Heger.)

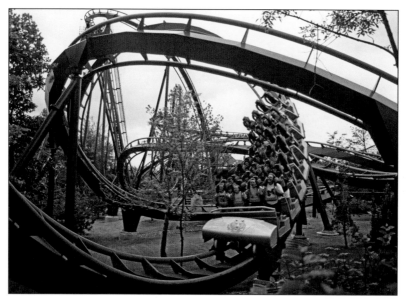

When it opened, Iron Wolf was the world's tallest and fastest looping stand-up roller coaster. The 100-foot-tall coaster featured a 90-foot drop, as well as two inversions, on its twisted course. Iron Wolf can be seen in the 1994 movie *Richie Rich*. (Photograph by Michael S. Horwood.)

Iron Wolf's last stand was on September 5, 2011. This was the last day for park guests to ride the stand-up coaster. Once the roller coaster closed after giving its last rides, a group of Six Flags employees paused for a farewell photograph in Iron Wolf's station. The coaster would leave for Six Flags America in Maryland to make room for a future attraction. Goliath would open in 2014 in this location. (Courtesy of Kyle Smith.)

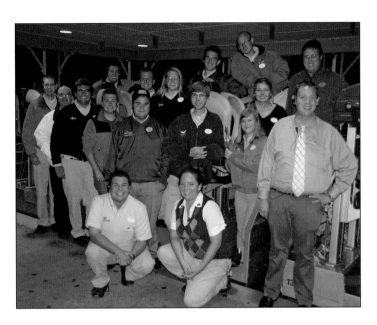

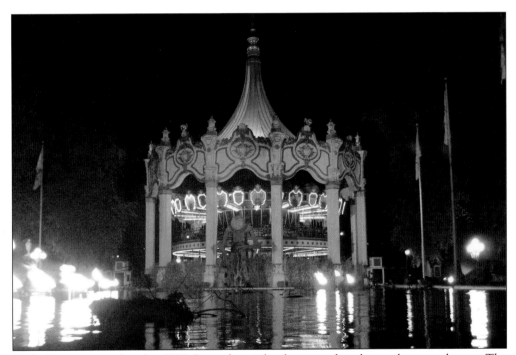

Fright Fest was introduced in 1991. Since then, it has become a hugely popular annual event. The park is completely transformed into a haunted wonderland. Extensive Halloween decorations are seen throughout the park. Several of the rides incorporate a special Halloween theme. Special shows are presented that are custom produced for Fright Fest. The first thing guests see when entering the park for Fright Fest is the Columbia Carousel's blood-red reflecting pool. (Photograph by Kyle Smith.)

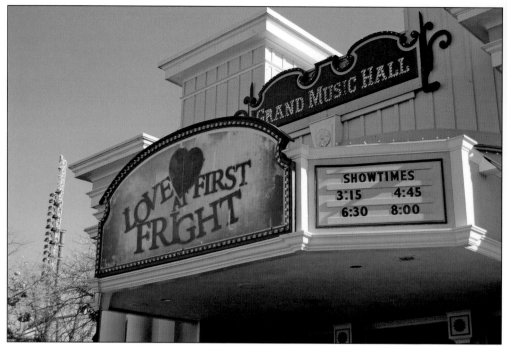

Love at First Fright, a haunted rock musical performed in the Grand Music Hall, proved to be enormously popular with audiences. It has become a must-see annual tradition for nearly all visitors to Fright Fest. (Photograph by Johnny Heger.)

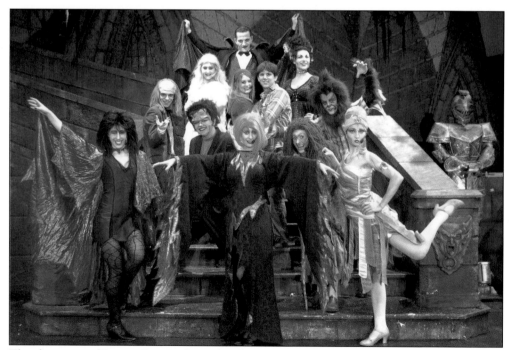

The characters of *Love at First Fright* are familiar to all who come to see the show year after year. They pause here to gather for a cast photograph. (Photograph by Sheila Dissmore.)

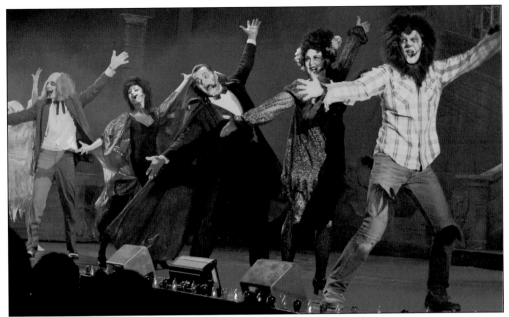

One of the best-loved parts of the show is the cast doing the "Time Warp" song and dance. While themed for Halloween, the show is meant to be appropriate for the whole family. (Photograph by Johnny Heger.)

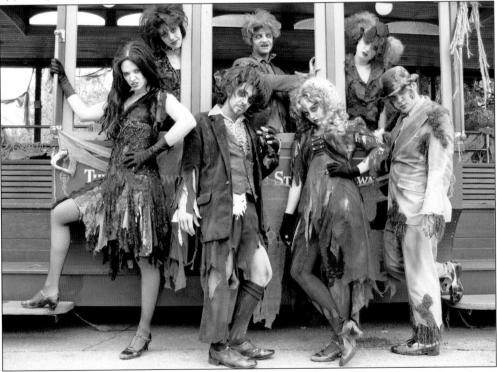

During Fright Fest, the park is invaded by all sorts of monsters, ghouls, zombies, and spooks. A group here has taken over the trolley. These invaders interact with guests during Fright Fest, adding to the scary experience. (Photograph by Sheila Dissmore.)

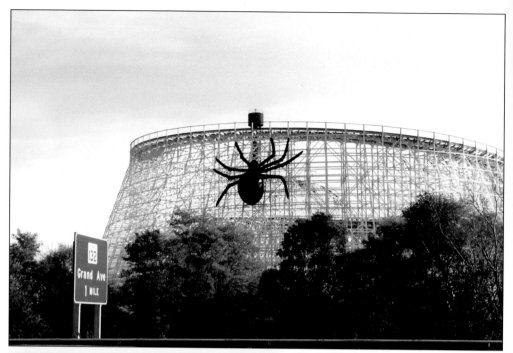

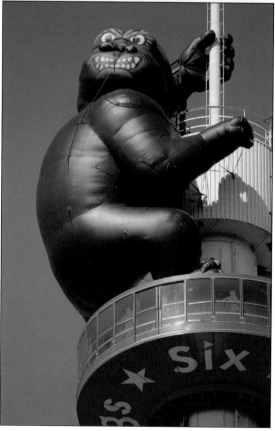

One of Fright Fest's most famous characters is Tiny, the giant spider that climbs the American Eagle next to the tollway each year. Eventually, Tiny was joined by three of her babies. Three local men risked their lives to kidnap Tiny from the American Eagle in 1994. Found safe days later, Tiny was returned to her place atop the roller coaster. In September 2012, the park announced Tiny's passing in an obituary released to the press. Later, Tiny was resurrected and reclaimed her perch in time for the 2013 Fright Fest. (Photograph by Sheila Dissmore.)

A new Fright Fest landmark first appeared atop the Sky Trek Tower in 2003. The giant gorilla was named Larry as the result of a contest held in 2005. Each year, the appearance of Larry the Gorilla atop the tower signals that the start of Fright Fest is near. He can be seen for miles around. (Photograph by Johnny Heger.)

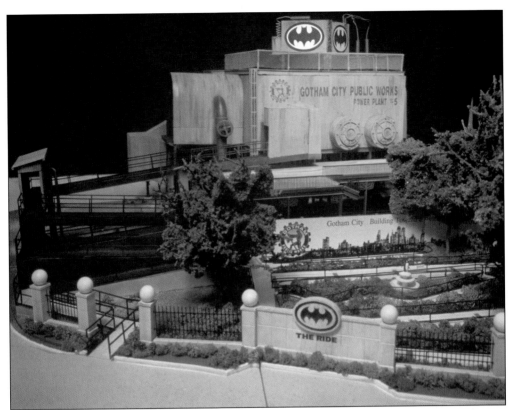

BATMAN: The Ride was a historic development for the park. In 1991, Six Flags came under the ownership of Time Warner Entertainment Company and its investment partners. This signaled the beginning of tie-ins with other Time Warner properties, including BATMAN. The year 1992 would bring the introduction of BATMAN: The Ride. It was a revolutionary roller coaster accompanied by an elaborate theming package. Seen here is a model of the Gotham City Park that would be built as the home of BATMAN: The Ride.

BATMAN: The Ride represented a breakthrough in roller coaster development. Six Flags turned to B&M to work on a roller coaster concept that would travel on the outside of the loop for the first time in history. The idea was a refinement of a proposal to make a roller coaster vehicle similar to a ski lift in which riders would hang below the track in a seat with their feet dangling free. Here, BATMAN: The Ride's second loop is being assembled.

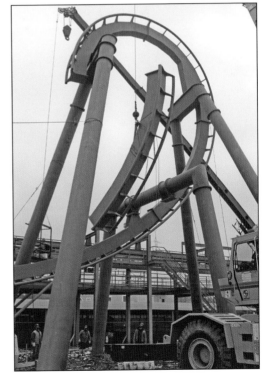

Former Six Flags Great America vice president and general manager Jim Wintrode tries out a seat in the station of BATMAN: The Ride during construction. Wintrode was instrumental in working with B&M on the development of this extraordinary roller coaster.

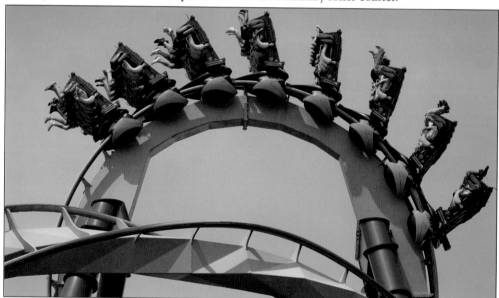

The dream was realized as a train on BATMAN: The Ride travels outside the loop. Originally, the entire structure was painted black. The new color scheme introduced in 2004 features yellow track and dark blue supports. BATMAN: The Ride was an astounding success. B&M went on to install duplicates and variations at Six Flags and other parks across the country and around the world. On June 20, 2005, BATMAN: The Ride was awarded Roller Coaster Landmark status by the American Coaster Enthusiasts in recognition of its historic significance. (Photograph by Johnny Heger.)

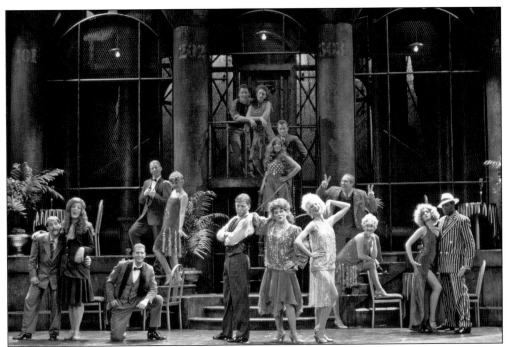

Six Flags continued to present a variety of great shows in the Grand Music Hall. Among the many memorable productions is *Chicago 1920: A New Gangster Musical.* This 1993 musical comedy featured the criminal escapades of the Stallone Gang and the efforts of character Elliott Mess to stop them. (Courtesy of David Carter.)

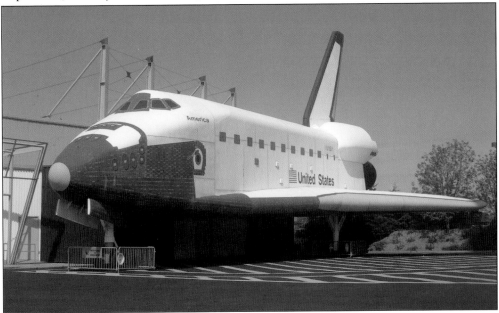

Space Shuttle America was a motion-based simulator attraction from Intamin added to Carousel Plaza in 1994. The audience was immersed in a simulated space travel experience as their seats moved in conjunction with the scenes of a film that took them to the fictional Armstrong City. (Photograph by Jon Revelle.)

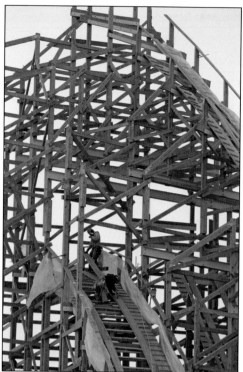

The wooden roller coaster Viper opened in 1995. One of the park's roller coaster gems, Viper is a mirror image of the famed Coney Island Cyclone roller coaster in New York. Six Flags Great America's own team built the Viper. The coaster's trains were supplied by Philadelphia Toboggan Coasters, Inc. The same company, known then as the Philadelphia Toboggan Company, also supplied the American Eagle's trains.

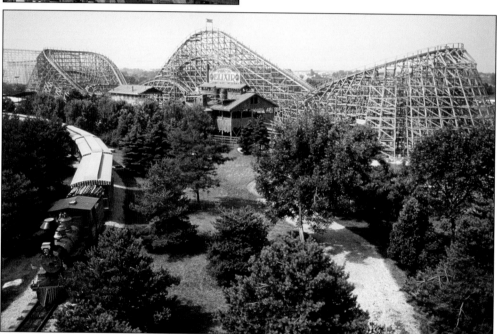

Located outside the perimeter loop defined by the railroad tracks, Viper opened a year ahead of the Southwest Territory that would be its home. The beautiful structure and the thrilling classic wooden roller coaster ride experience it provided were welcome additions to the park. While the American Eagle offers a racing, out-and-back–style roller coaster ride, Viper gives guests the opportunity to experience an intense twister-style wooden roller coaster ride.

Standing 100 feet high, Viper has a first drop of 80 feet for the thrilling start of nonstop roller coaster action. Riders on Viper are treated to a rambunctious high-speed journey through drops and climbs and twists and turns, all as the train races in and out of the wooden structure.

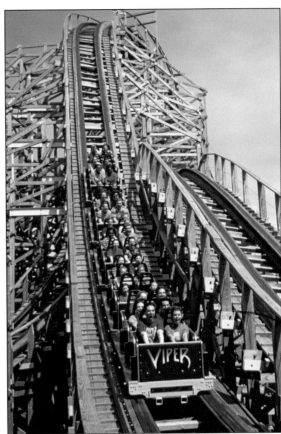

Southwest Territory opened in May 1996, twenty years after the opening of the park. Marriott announced its Great Southwest in 1977 with plans for a 1979 opening. The name may have been a nod to Six Flags founder Angus G. Wynne Jr.'s Great Southwest Corporation. The first project of Randall Duell's firm was to complete the design of the first Six Flags park, Six Flags Over Texas, for Wynne's company. Marriott's plans to build the Great Southwest were never realized. Six Flags instead built its own vision of the Great Southwest, naming it Southwest Territory. (Photograph by author.)

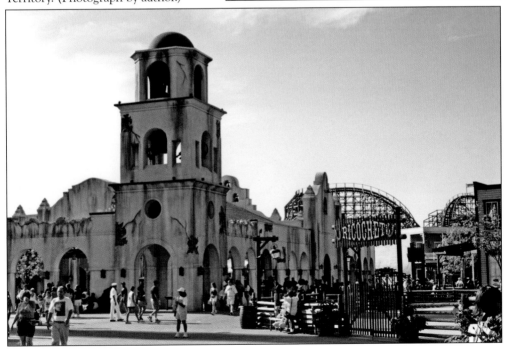

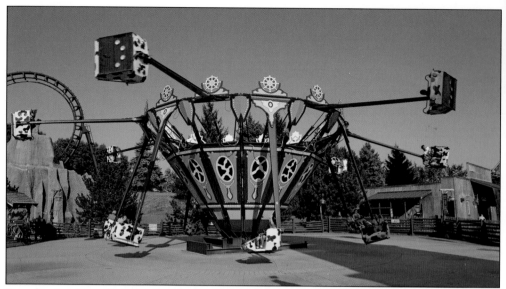

Ricochet is a Huss Swing Around ride. Originally named Big Top, it was added to the park in County Fair as part of the 1977 expansion. With new theming and a new color scheme, the ride was moved to the new Southwest Territory for the 1996 season. The spinning ride gives riders a unique sensation as it flings them up high while the ride rotates. (Photograph by author.)

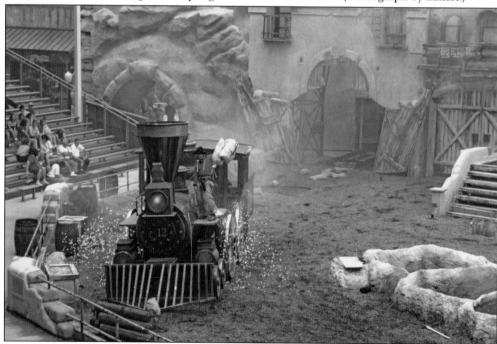

The Warner Bros. Western Stunt Show was an exciting live-action show that incorporated elements from Warner Bros. classics such as *F Troop*, *Blazing Saddles*, and *Maverick*. The out-of-control steam locomotive rushing toward the audience was just one of the many exciting features of the show. The arena originally hosted the BATMAN Stunt Show starting in 1993. In 1996, it became part of the new Southwest Territory and home to the Warner Bros. Western Stunt Show. (Courtesy of David Carter.)

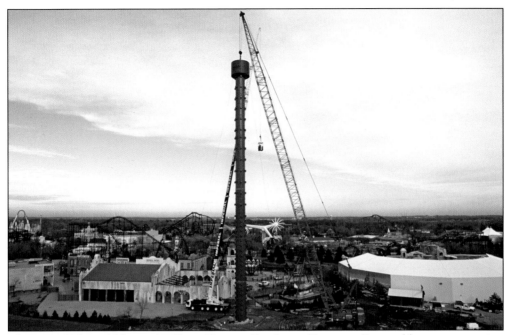

The year 1997 would bring the Giant Drop to Southwest Territory. Pictured here, construction reached a milestone when the tower was topped out at more than 200 feet.

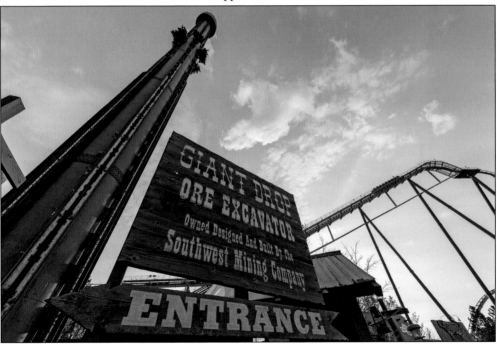

The Giant Drop represents a new generation of free-fall ride in the tradition of 1983's The Edge. Six four-passenger cars are lifted swiftly up the tower. At the top, following a brief pause, the cars are detached from the lift mechanism and drop in free fall to the ground. An innovative magnetic braking system brings the cars to a safe stop at the ground. Also seen in this view is 1999's Raging Bull roller coaster. (Photograph by Ryan MacKenzie.)

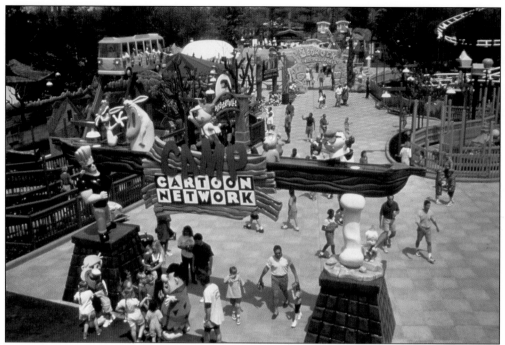

Camp Cartoon Network was introduced in Yukon Territory in 1998. That same year, also in Yukon Territory, the area for children that was originally known as Fort Fun and later BUGS BUNNY LAND became LOONEY TUNES NATIONAL PARK. Camp Cartoon Network brought in family rides and attractions based on cartoons such as *THE FLINTSTONES*; *THE JETSONS*; *SCOOBY-DOO, WHERE ARE YOU!*; and *THE YOGI BEAR SHOW*. The area today is known simply as Camp Cartoon.

Spacely's Sprocket Rockets is Camp Cartoon's roller coaster. Manufactured by Vekoma of the Netherlands, Spacely's Sprocket Rockets was added as part of Camp Cartoon Network in 1998. An unusual feature of this coaster is that instead of a chain lift, motor-driven rubber tires are used to drive the coaster train to the top of the lift hill. (Photograph by Duane Marden/rcdb.com.)

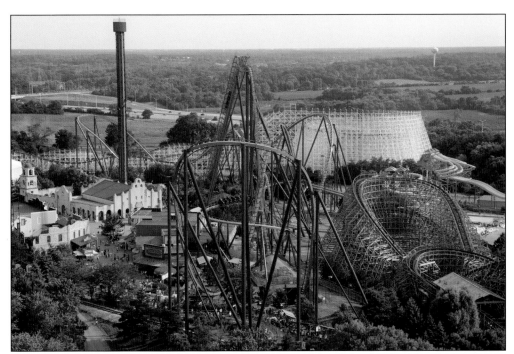

B&M was called upon again to add to Six Flags Great America's roller coaster lineup for 1999. This time, the company came up with Raging Bull, described as the first hyper twister roller coaster. It is called a hyper coaster because, at 202 feet tall, it exceeds 200 feet in height. It is called a twister because, in the tradition of Viper and its Coney Island Cyclone inspiration, the track follows a course of twists and turns, crossing over and under itself multiple times. (Photograph by author.)

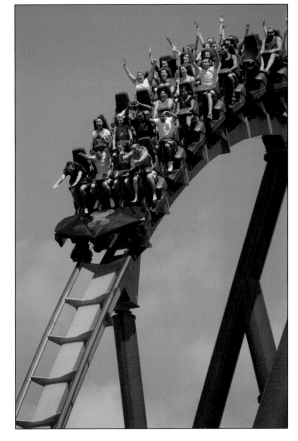

Raging Bull remains the park's most popular ride. Starting with the 208-foot drop into a tunnel, Raging Bull delivers an ultra-smooth, high-speed trip around Southwest Territory with plenty of drops, twists, turns, and "air time." (Photograph by author.)

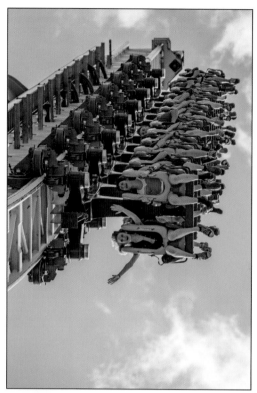

Two major roller coasters were added in 2001. The first to open was V2: Vertical Velocity. Located in Yankee Harbor, Vertical Velocity is an Intamin Twisted Impulse roller coaster. The inverted coaster train is launched out of the station at ground level via linear motors. As a shuttle ride, the train goes back and forth, climbing a twisted vertical track in front and a straight vertical track in the back. (Photograph by Ryan MacKenzie.)

Opening later in 2001 was Déjà Vu. The new roller coaster was situated on the site of the iconic Sky Whirl, which made its final spin in 2000. Manufactured by Vekoma, Déjà Vu was known as a Giant Inverted Boomerang roller coaster. The single inverted train shuttled between two giant towers that were just under 200 feet tall. Riders experienced vertical drops and three inversions both forwards and backwards. (Photograph by Mark Rosenzweig.)

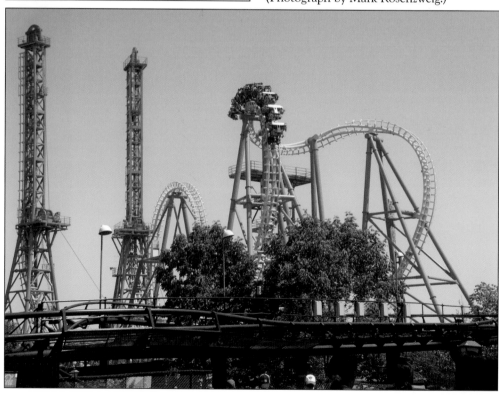

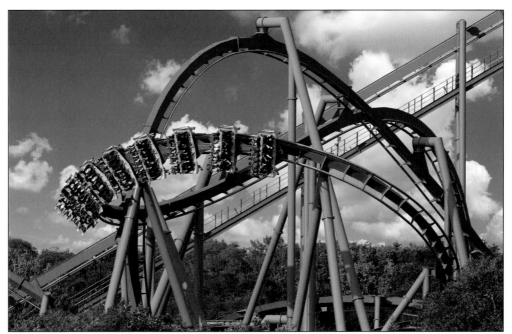

B&M's next installation at Six Flags Great America would be 2003's SUPERMAN: Ultimate Flight. Classified as a flying coaster, SUPERMAN: Ultimate Flight gives riders an experience much like flying through the air as SUPERMAN. Situated on the site previously occupied by Shock Wave, SUPERMAN: Ultimate Flight reaches a height of 106 feet with a maximum drop of 100 feet.

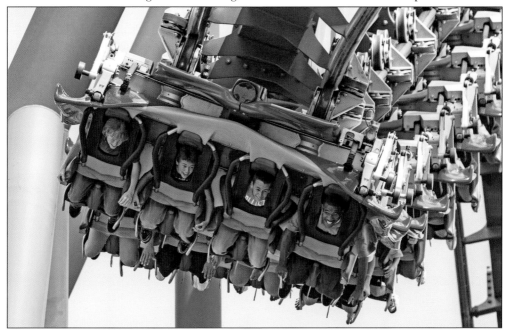

Guests board the trains on SUPERMAN: Ultimate Flight while the seats are in an upright, normal position. After all of the safety harnesses are locked into place, the seats rotate to position riders face-down. This enables them to enjoy the entire ride in the flying position, as seen here. (Photograph by author.)

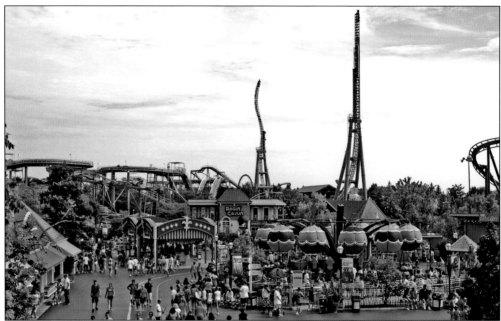

The section of Orleans Place between the railroad trestle and Yankee Harbor was transformed into the new Mardi Gras area, which opened in 2004. The Ragin' Cajun, a Wild Mouse–style roller coaster, was a highlight of the new Mardi Gras. The coaster, however, departed for Six Flags America in Maryland following the 2013 season. (Photograph by Kyle Smith.)

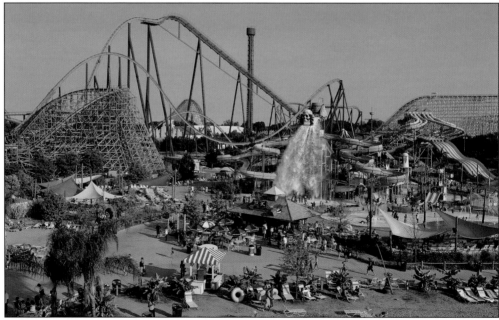

Hurricane Harbor, opened in 2005, was Six Flags Great America's largest expansion since the addition of the Southwest Territory in 1996. A full-sized water park within the park, Hurricane Harbor is free to season pass holders. Among Hurricane Harbor's initial offerings were a large number of world-class waterslides, the Hurricane Bay 500,000-gallon wave pool, and the Castaway Creek lazy river.

Hurricane Harbor provides splashing good fun for everyone. Myriad water attractions offer gentle fun for the little ones, daring thrills for the more adventurous, as well as easygoing activities for all ages. The large blue-and-yellow funnel seen at upper right is the massive Tornado waterslide that was added in 2006. (Photograph by Kyle Smith.)

Wiggles World came to Six Flags Great America in 2007, housed in the large tent and adjacent area in County Fair. The tent had been part of the Grandstand Pavilion that housed the circus and was later converted to a queue area for the American Eagle. The Wiggles were an Australian band popular with children. Wiggles World featured new rides, a show, and a food outlet that were themed to the Wiggles. The Wiggles World Fruit Salad ride is seen here. Later, all references to the Wiggles were removed, and the area was renamed Kidzopolis. (Photograph by Johnny Heger.)

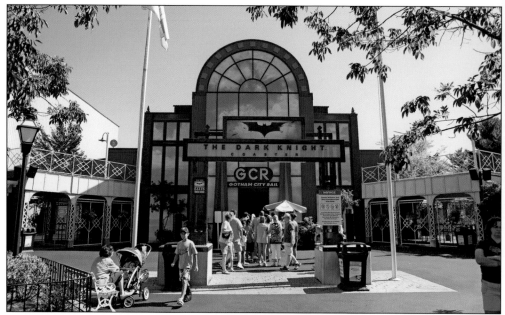

THE DARK KNIGHT™ Coaster arrived in Orleans Place in 2008. A Wild Mouse coaster manufactured by Mack Rides of Germany, THE DARK KNIGHT Coaster is enclosed in darkness inside its own building. The Theatre Royale show venue was converted into a queue building for the coaster. However, the building enclosing the coaster is actually adjacent to the former Theatre Royale. The ride is themed to represent the Gotham City Rail transit system. (Photograph by author.)

Buccaneer Battle is a wild water adventure manufactured by Mack Rides of Germany. Eight passengers set sail on each ship. Using super soaker guns, they battle it out with each other, getting everyone soaked. That is not all, however. Guests on shore engage in water-spraying matches with those on the ships, too. Opened in 2009, this family attraction sits on the former site of the Déjà Vu roller coaster and the Sky Whirl triple Ferris wheel that came before it.

Six Flags Great America park president Hank Salemi addresses the audience at the opening ceremony of the Little Dipper roller coaster on May 27, 2010. A junior coaster designed by Herbert Schmeck from Philadelphia Toboggan Company, the Little Dipper had long been a beloved part of growing up in Chicagoland. The Little Dipper originally opened in 1950 at Kiddieland in Melrose Park. On the podium, too, are Cathy Norini and Ron Rynes Jr., co-owners of Kiddieland. They presented to Six Flags Great America the Little Dipper's Coaster Classic award plaque from the American Coaster Enthusiasts so that it could remain with the ride it honors. (Photograph by Duane Marden/rcdb.com.)

The Little Dipper's relocation was a wonderful success story of roller coaster preservation. Hank Salemi purchased the coaster at auction following Kiddieland's permanent closure. His team took great care in documenting the ride and reassembling it at Six Flags Great America. Children may not know much about historic preservation, but they know that the Little Dipper is a whole lot of fun. (Photograph by Kyle Smith.)

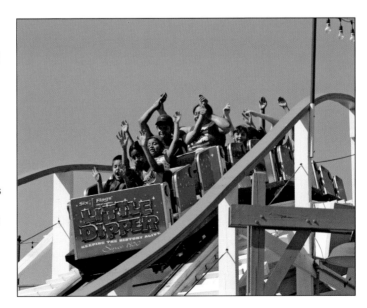

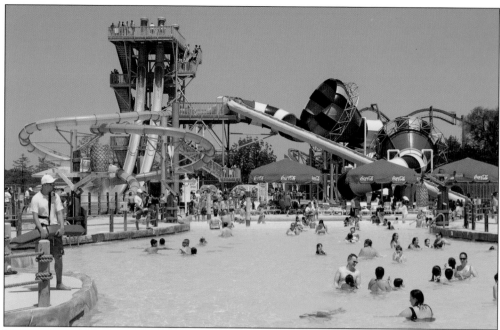

Hurricane Harbor was expanded by approximately four acres in 2011 with the addition of Riptide Bay. The whole family can enjoy Riptide Bay's new luxury cabanas and Monsoon Lagoon, a 14,000-square-foot pool with waterfalls and seven spray columns. Above on the left, the new Dive Bomber and Mega Wedgie maximum-thrill water slides drop daring guests through trap doors into either enclosed loops or near-vertical drops. Meanwhile, the Surf Rider provides a simulated surfing experience. Riptide Bay's Wipeout slide, pictured below, takes guests on four-passenger rafts through two funnels and enclosed twisting tunnels. (Photograph below by Kyle Smith.)

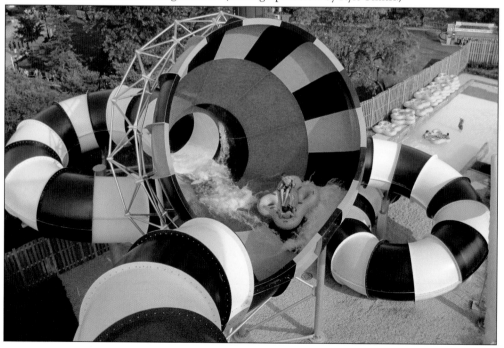

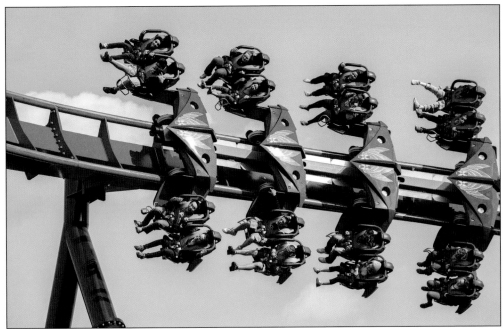

Six Flags Great America added another B&M coaster to its collection in 2012 with the introduction of X Flight. On X Flight, the seats are cantilevered out on each side of the track, creating a ride experience without track above or below the riders. X Flight was built on the site of the original Barney Oldfield Speedway and also Splashwater Falls. Below, a thrilling moment on X Flight is seen here as the train slices through the aircraft control tower. This is just one instance during the ride in which seemingly too-tight clearances add to the excitement. (Photograph above by Ryan MacKenzie.)

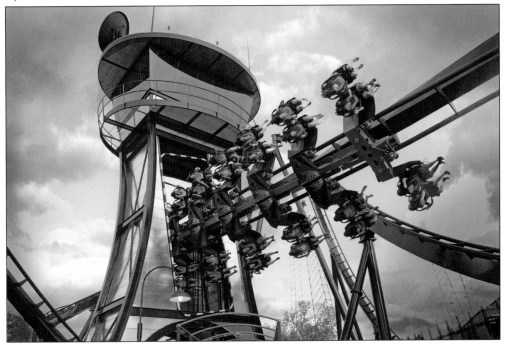

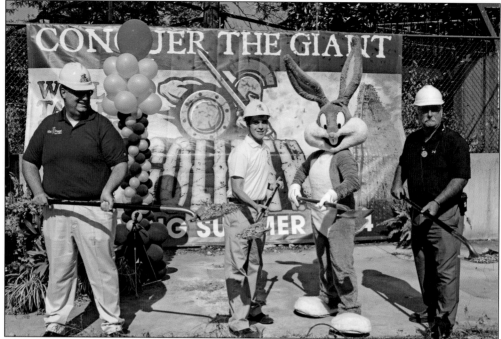

On August 29, 2013, from left to right, Hank Salemi, Six Flags Great America park president; Dylan Druktenis, portraying David; BUGS BUNNY; and Gary Pohlman, Six Flags Great America director of maintenance, broke ground to mark the beginning of construction of Goliath, a new roller coaster for 2014. The park's fourth wooden roller coaster, Goliath features new technology, whereas the American Eagle, Viper, and Little Dipper are built with traditional wooden roller coaster technology. (Photograph by Jon Revelle.)

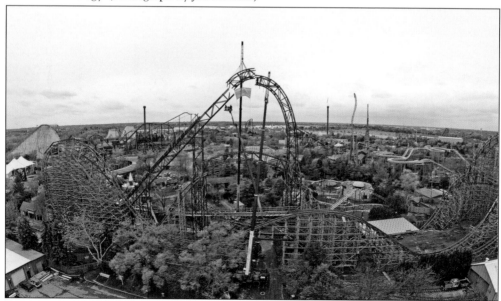

Goliath's structure was topped out on May 16, 2014. The radical new roller coaster was built by Rocky Mountain Construction Company of Hayden, Idaho. Goliath would open just over a month later, on June 19, 2014. (Photograph by Duane Marden/rcdb.com.)

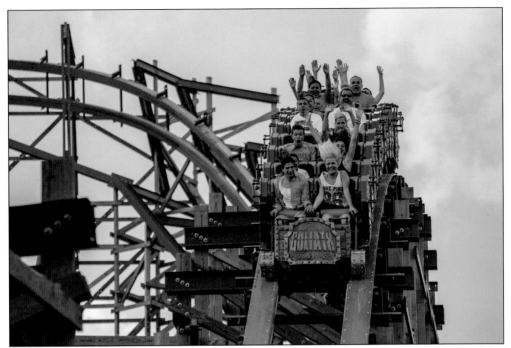

Goliath immediately became a huge hit with guests at Six Flags Great America. The popular coaster was certified by Guinness World Records for three wooden roller coaster world records: fastest at 71.89 miles per hour, tallest at 180 feet, and steepest at 85.13 degrees. (Photograph by Ryan MacKenzie.)

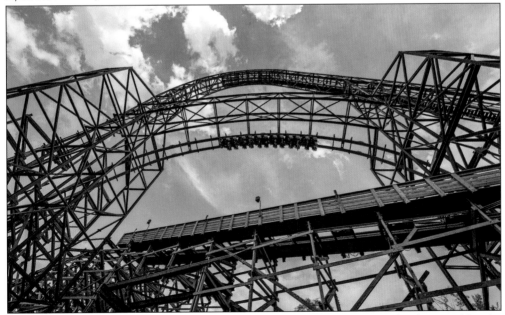

Rocky Mountain Construction Company's new wooden roller coaster technology enables the implementation of elements not feasible on traditional wooden roller coasters. Here, the train on Goliath crests a hill below the lift, having twisted completely upside down. This element is called a zero-g stall. (Photograph by Ryan MacKenzie.)

For 2016, the park's 40th anniversary season, the Southwest Territory Amphitheater gave way to the new Hall of Justice to house the incredible 4-D interactive attraction JUSTICE LEAGUE™: Battle for Metropolis. Guests are immersed in an amazing experience that includes high-definition 3-D animation, 4-D effects such as wind, fire, mist, and fog, and animatronic characters. Motion vehicles take guests on a journey through the streets of Metropolis as they battle LEX LUTHOR™ and THE JOKER to foil their evil plot.

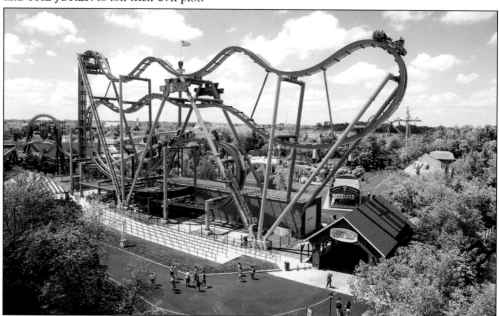

THE JOKER free-fly coaster was added for the 2017 season. Standing 120 feet tall, THE JOKER is a 4D Free Spin coaster manufactured by S&S–Sansei Technologies. It features vehicles with free-spinning seats cantilevered outside both sides of the track. Magnetic fins induce head-over-heels flips as the cars traverse a stacked track of speed bumps and two extreme, beyond-vertical raven drops. To place THE JOKER in Yankee Harbor, the East River Crawler was moved to Hometown Square and restored to its original name, the Lobster. The covered bridge between Orleans Place and Yankee Harbor was moved a short distance to make room for THE JOKER.

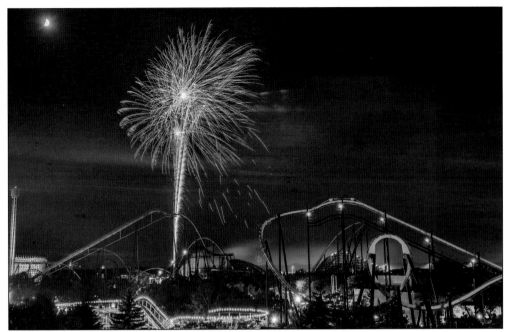

Six Flags Great America is a perfect place to celebrate the country's Independence Day. Fourth of July fireworks have long been a park tradition. The magic of the park at night with fireworks lighting up the sky is an experience treasured by many, year after year. (Photograph by Ryan MacKenzie.)

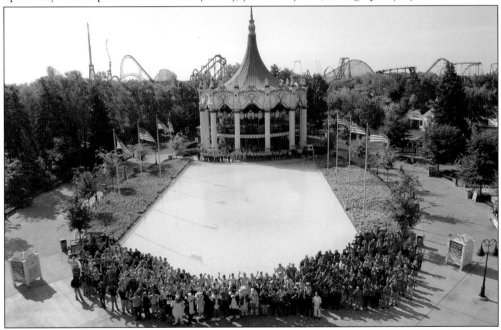

To honor the park's 40th season and 40th anniversary, Six Flags Great America employees gathered at the Columbia Carousel's reflecting pool to reenact the 1976 employee "family portrait" that appears on the front cover. Just like all who came before them, today's park employees are the ones who make it happen, the ones who still make Six Flags Great America the "country of fun for everyone."

DISCOVER THOUSANDS OF LOCAL HISTORY BOOKS FEATURING MILLIONS OF VINTAGE IMAGES

Arcadia Publishing, the leading local history publisher in the United States, is committed to making history accessible and meaningful through publishing books that celebrate and preserve the heritage of America's people and places.

Find more books like this at
www.arcadiapublishing.com

Search for your hometown history, your old stomping grounds, and even your favorite sports team.